EDINBURGH

THROUGH TIME

Liz Hanson

AMBERLEY PUBLISHING

Bibliography

A Traveller's Companion to Edinburgh by David Daiches
Auld Reekie by Alastair Alpin MacGregor
Discovering the Water of Leith by Hamish Coghill
Edinburgh – A History of the City by Michael Fry
Lost Edinburgh by Hamish Coghill
Ordnance Gazeteer of Scotland – Francis Groome
Princes Street, Edinburgh Pub by The Life Association of Scotland
South Edinburgh by Malcolm Cant
The Buildings of Scotland – Edinburgh by Gifford, McWilliam and Walker
The Scottish Episcopal Church – A New History by Gavin White
4 Gardens in One by Deni Brown (HMSO)

To Shona, for her support

First published 2012

Amberley Publishing
The Hill, Stroud
Gloucestershire, GL5 4EP

www.amberley-books.com

Copyright © Liz Hanson, 2012

The right of Liz Hanson to be identified as the
Author of this work has been asserted in accordance
with the Copyrights, Designs and Patents Act 1988.

ISBN 978 1 4456 0707 8

British Library Cataloguing in Publication Data.
A catalogue record for this book is available from
the British Library.

Typeset in 9.5pt on 12pt Celeste.
Typesetting by Amberley Publishing.
Printed in the UK.

Introduction

The history of Edinburgh is not for the faint hearted. Between the foundation of the royal burgh in 1130 and the cosmopolitan city of today, are nearly nine centuries packed with drama, battles, uprisings and religious convolutions interlaced with innovation, discovery, achievement and creativity. Much of the story is stitched together with a jagged thread – that of the struggle against domination by England.

Volcanic eruptions millions of years ago, followed by sheets of ice scouring away all but the hardest rocks, were the natural events responsible to the topography of Edinburgh. The plug of Castle Rock and the tail of the Royal Mile formed the very heart of the city.

King David I built the Castle on what had previously been merely a fortified settlement, but the most obvious vantage point. The oldest surviving building in Edinburgh is St Margaret's Chapel at the Castle (approximately AD 1100), dedicated by David to his mother. He also founded Holyrood Abbey at the other end of this geological formation, around which the burgh of Canongate was formed in 1140 and where the monks started market gardens, pastoral farming and small industries such as salt extraction. In addition the parish church of St Giles was erected, and from this embryonic layout, the development of the Old Town began.

By the end of the thirteenth century, Alexander III had died and Edward I had invaded Berwick and Dunbar and captured Edinburgh Castle. Amongst other artefacts, he stole the Stone of Destiny, which finally returned to Scotland in 1996. William Wallace unsuccessfully attempted to overcome the English occupation but it was Robert the Bruce who defeated the English army at Bannockburn in 1314 to regain the Castle, which changed hands twice again until David II rebuilt and enlarged the fortification in 1356.

By 1500, there were around 12,000 people living within the confines of Castlehill, Lawnmarket, and Canongate and the parallel street at the foot of the southern slope – Cowgate – together with the narrow closes joining the two streets; the town walls prevented outer expansion, so new houses were built on top of existing ones. The wonder of 'medieval high-rise' is now a major attraction of the High Street. However, back then, the practical problems were immense. Livestock, too, shared this space and with no piped water, and enormous volumes of waste, our twenty-first-century sensibilities can barely think about how insanitary, filthy and stinking the conditions were. It was noisy too and riots and brawls became commonplace.

After defeat at Flodden in 1513, when James IV was killed, Edinburgh entered a very turbulent period. Henry VIII attempted to arrange a marriage of the infant Mary Queen of Scots to his young son Edward but was unsuccessful and, in his rage, sent the Earl of Hertford to burn the city in 1544. In 1558, religious violence erupted, led by the Protestant Reformer, John

Knox, railing against the Catholicism of Mary Queen of Scots' reign and by 1560, the parliament announced Protestantism to be the religion of Scotland. Although Mary returned from France the next year, she abdicated, enabling her son James IV to become King and it was from his charter for a Town College that University of Edinburgh evolved.

Until now, parliament had met in The Tolbooth, sharing the restricted space with the Town Council and Court of Session but Charles I was enthusiastic to build Parliament House, adjacent to St Giles in 1640, although sixty-seven years later, Scottish and English Parliaments joined under the Treaty of Union in 1707. At the time of writing, the issue of an independent Scottish Parliament is once again being debated. Throughout the seventeenth century, politics and religion continued to cause strife, particularly concerning the Covenanters. In the midst of this, however, Scots Law was being formulated by Sir George Mackenzie and spawned legal expertise with which Edinburgh subsequently became synonymous. Medicine, too, came to the fore, and together with writers, philosophers and advocates, a cultural and enlightened elite began to flourish.

By the mid-eighteenth century, a critical point was reached. Old Town was desperately overcrowded and a proposal was put to the Town Council to create a New Town across the Nor' Loch valley to the North. In the 1770s, North Bridge spanned the chasm, the loch was drained and the first phase of James Craig's winning design was started. The houses were elegant, classical and desirable, causing an exodus from the grimy tenements of the High Street, and a new, more peaceful era began in the history of Edinburgh.

The boundaries of the city have spread in all directions since, and in 1920, the Burgh of Leith was integrated. In 1946, the Edinburgh International Festival was started and, together with the (now larger) Festival Fringe, as well as Book, Film and TV festivals, contributes to both the economy and visitor numbers during August.

Both Old and New Towns are UNESCO World Heritage sites.

Acknowledgements

I am grateful to the many people who have helped in diverse ways to complete this book.

Special mentions must go to the following individuals: Anne Sharkey, David Brown, Shauna Hay at Royal Botanic Garden Edinburgh, Margaret Maxwell, Sarah Kane, and Andrew Kerr. I would also like to thank the staff of the Edinburgh and Scottish Collection at Central Library, for whom nothing is too much trouble, and Peter Stubbs, whose exhaustive archive at edinphoto.org.uk has proved fertile ground.

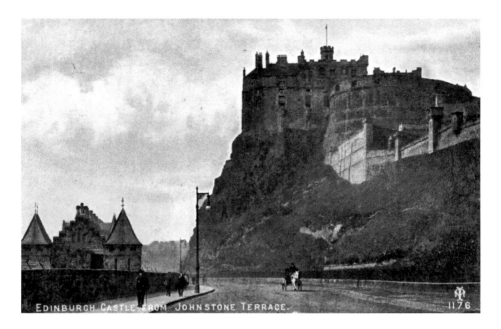

Edinburgh Castle from Johnstone Terrace

The citadel of Edinburgh Castle, perched on a steep plug of volcanic rock, is virtually impenetrable other than from the entrance at Castlehill. This defensive location had been essential during the troubled preceding centuries. Despite this, an additional five-storey fortification – David's Tower – built by David II in 1368, succumbed to a prolonged and vicious pounding by the Protestant army of Elizabeth I while Mary, Queen of Scots was imprisoned. The half-moon battery was erected on its foundations, allowing cannon to fire across a broad sweep of country to the East.

The thoroughfare of Johnstone Terrace was hewn out of the castle rock in 1827 to create a link between Lawnmarket and the Union Canal terminus at Lothian Road.

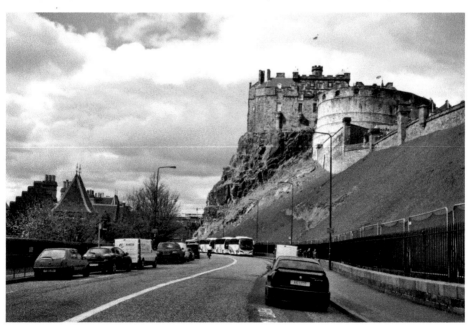

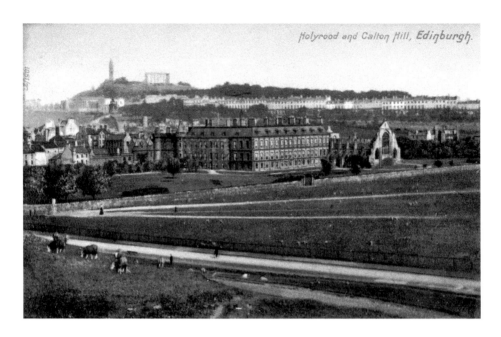

Palace of Holyroodhouse and Calton Hill

At the foot of Old Town lie the ruins of Holyrood Abbey, founded by David I in 1128 for Augustinian monks but used by the residents of neighbouring Canongate burgh as their parish church right up until 1688, despite immense damaged being inflicted on the abbey by both Reformers and the English.

The palace was not built until 1498, when James IV decided to extend the royal quarters at the abbey. Over the next two centuries the story of this accommodation is peppered with a cycle of fire, rebuilding, pillage, reconstruction and attack until, during the reign of Charles II (1660–85), major work was undertaken to integrate all the ruins into a proper royal palace. The result is what we see today, still used by the present royal family.

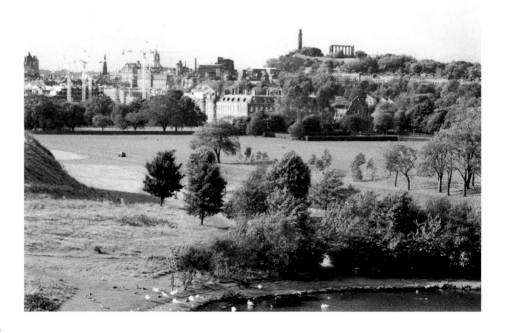

Heart of Midlothian

The attractive cobbled shape on the pavement near St Giles Cathedral belies the dark history behind it. In 1561, a custom-house known as the Old Tolbooth was built at an odd angle in the Lawnmarket. During its 250-year existence, it was used initially as the town hall and meeting place for both parliament and Court of Session, but in 1640 it became the city's jail and executions took place outside. The spot where the gallows stood is known as Heart of Midlothian, the name given to it by Walter Scott. He collected Edinburgh memorabilia for his home in Abbotsford, near Melrose, and the door of a condemned cell from Old Tolbooth is in his collection. Accounts of deplorable and insanitary conditions in the jail made imprisonment there a punishment in itself.

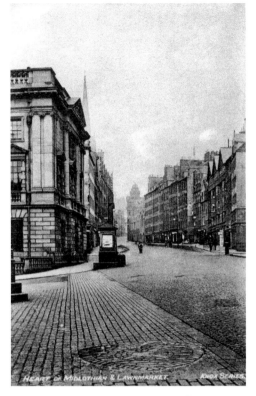

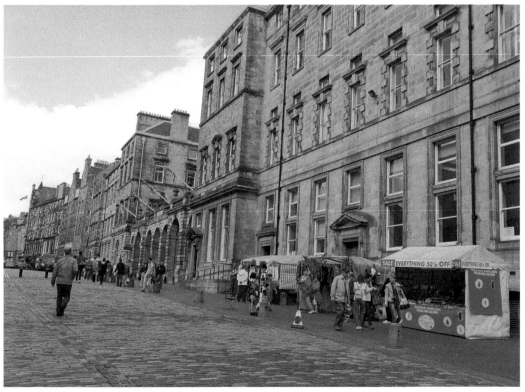

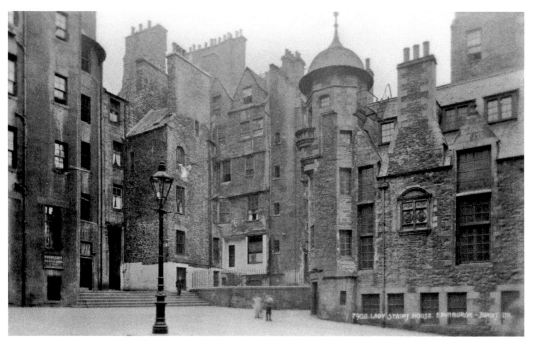

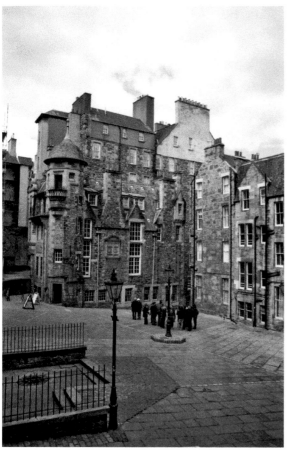

Lady Stairs Close

The layout of medieval Edinburgh centred around the sloping spine between the castle and Holyrood, lined with tall tenements known as 'lands'. Between them, at right angles, were more than 100 steep closes and wynds (the latter being wide enough for a horse and cart) connecting the two parallel valleys of Cowgate and Nor' Loch. They were named either for their function, such as Fleshmarket Close or Bakehouse Close, or after the owners of the building, such as this one. The original house of 1622 was built by Sir Walter Gray and then sold to Lady Stairs. A descendant of hers, Lord Rosebery, restored it in 1893 and subsequently gifted it to the city. Presently, it is the Writer's Museum, featuring collections from Robert Burns, Robert Louis Stevenson and Walter Scott.

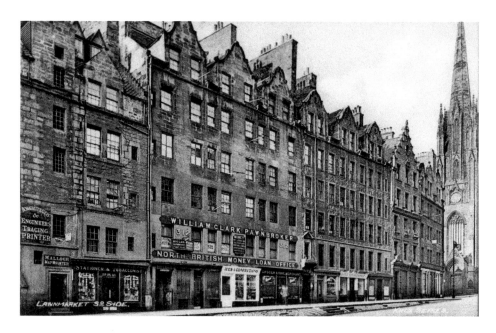

Lawnmarket

The Royal Mile, as it is now known, consisted of three named sections – Castlehill, leading to Lawnmarket and then Canongate, which was a separate burgh, below Netherbow Port.

The area surrounding St Giles was where market stalls called luckenbooths – literally, locked stalls – regularly set up markets to sell their wares. They were chaotic, noisy affairs, cluttering streets already filthy with human and animal waste!

On the north side of Lawnmarket, there survives a six-storey, seventeenth-century tenement which belonged to a merchant called Thomas Gledstane. Now named Gladstones Land, the house is managed by National Trust for Scotland and allows a glimpse of living space during medieval times, but without noise and stench!

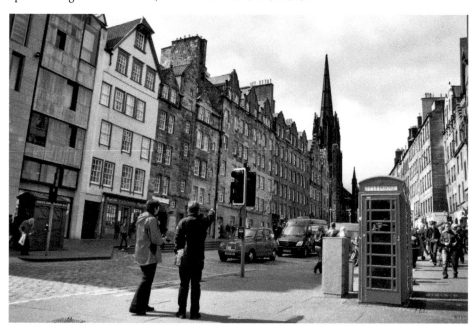

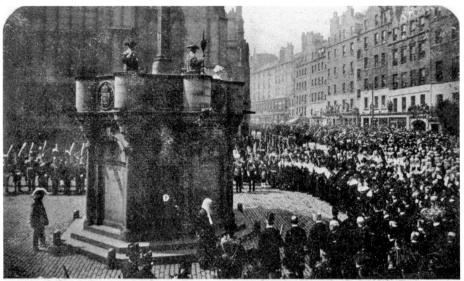

PROCLAMATION OF KING GEORGE V. AT THE MERCAT CROSS, EDINBURGH.
BY LORD PROVOST BROWN, 10TH MAY 1910

Mercat Cross

A gathering place from which royal, and other, proclamations were (and still are) made to the populace. The present structure only dates back to 1885, albeit incorporating pieces of the fifteenth-century original, which was broken during reconstruction in 1617. In 1756 the cross was taken away altogether and stored at Drum House on the southern outskirts of town but William Gladstone paid for it to be repaired and reinstated. Edinburgh Corporation renewed the shaft in 1970.

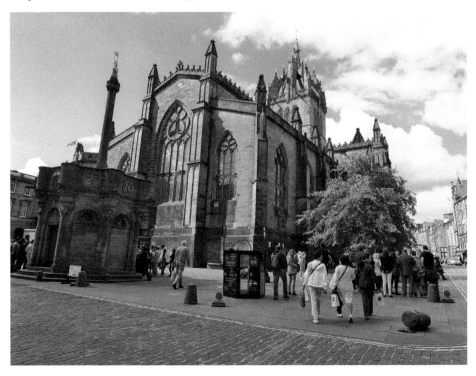

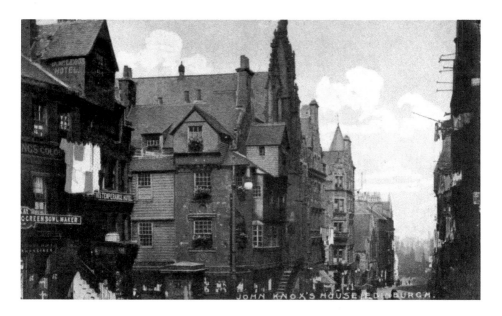

John Knox House

This is one of the oldest surviving fifteenth-century tenements in Edinburgh, thought to be the home of the Protestant Reformer during the reign of Mary, Queen of Scots. Due to chronic shortage of space in Old Town, living accommodation had to be built upwards, so a typical property consisted of two houses built on top of each other with a shop on the street level, whose frontage was arcaded. Livestock and fuel could be stored under the forestairs.

Next to John Knox House, behind the well-head is Moubray House, built in 1477, one of whose occupants was Daniel Defoe, author of *Robinson Crusoe*. This property has recently been gifted to Historic Scotland by the American owner.

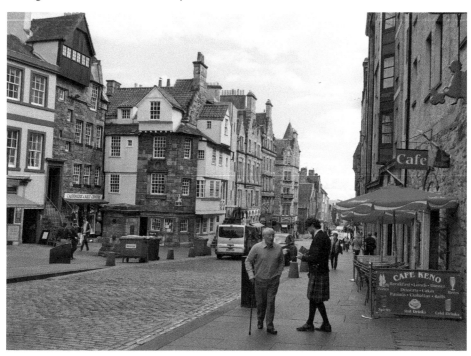

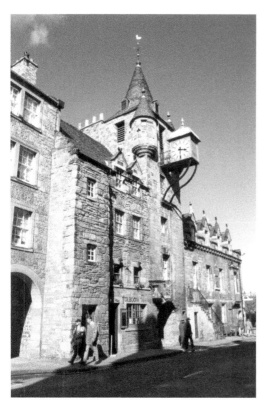

Canongate

The burgh of Canongate at the lower end of Old Town was formally integrated into Edinburgh in 1856, having thrived as an independent community since its foundation in the twelfth century. Thirty years after Edinburgh's Old Tolbooth was built, Canongate erected its own, which, unlike the neighbouring one, is still standing and used as 'The People's Story' museum currently. Many Covenanters were imprisoned there between 1661 and 1688.

By the middle of twentieth century, Canongate was a shadow of its former self. Depopulation and shabby housing precipitated the decision to renovate the area in the 1960s and then, more recently, it was chosen as the preferred site for the new Scottish Parliament, which, with the attendant upsurge in smart hotels, shops and desirable accommodation, has given Canongate a new lease of life.

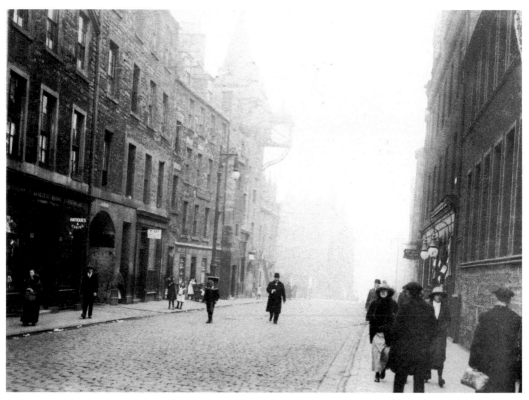

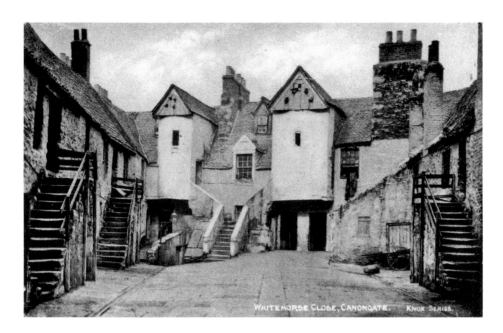

WHITEHORSE CLOSE, CANONGATE. KNOX SERIES.

White Horse Close

This enclosure was the royal mews in the sixteenth century, where horses were stabled for Holyrood. The houses seen now were built by a man named Laurence Ord in 1600s, together with an inn at the far end. It was he who named the close after 'the white horse of Hanover', said to be the favourite nag of Mary, Queen of Scots. The Jacobite army of Bonnie Prince Charlie were billeted at the inn when they made the short sojourn to Edinburgh in 1745. Three hundred years later, the properties had become dilapidated and unfit for living accommodation, but were thankfully restored in the 1960s, transforming the close to one of the most attractive in the Royal Mile.

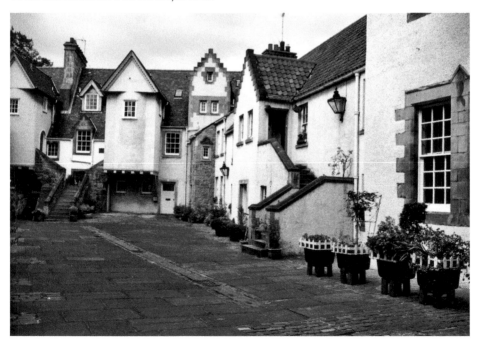

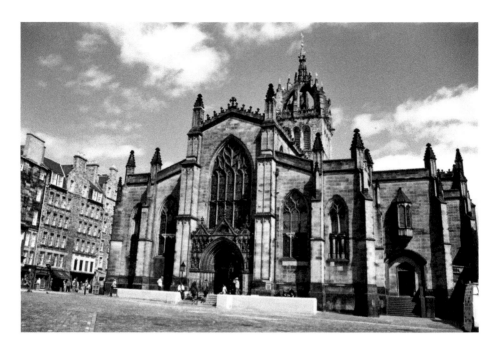

St Giles Cathedral

The High Kirk of Edinburgh seen today in the Royal Mile has only one capital from the original cathedral, but the ecclesiastic location has been central to Edinburgh's religious life for nearly 900 years. Prior to the Reformation, St Giles was the sole parish church of the town and the area surrounding it, used as a burial ground. The latter was covered over when the first Parliament House was built in 1640.

The environs of St Giles were always teeming with activity in medieval Edinburgh; the formidable bulk of Old Tolbooth was virtually adjacent to the north-west wall and a place where town councillors, provosts and merchants would necessarily brush shoulders with local residents and market traders, who sold goods from their luckenbooths, dotted around both buildings.

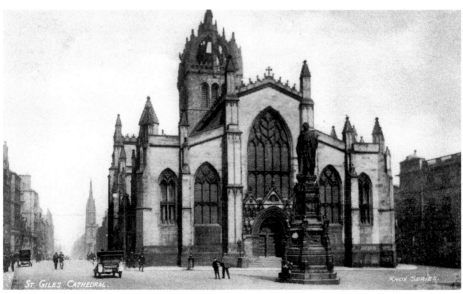

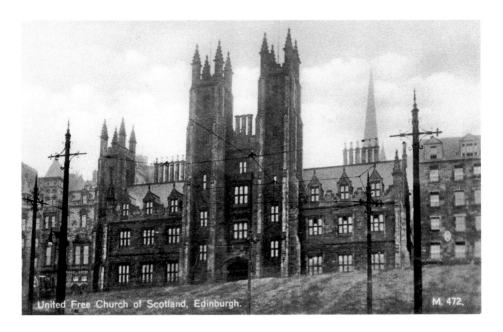

United Free Church of Scotland, Edinburgh. M. 472.

New College and Assembly Hall

In 1843, the established Church of Scotland fractured over the issue of spiritual independence from the State, a religious conflict known as the Disruption. The splinter group became The Free Kirk, and the imposing New College for the education of its ministers was erected in 1859 overlooking The Mound. In the twentieth century, the majority of Free Churches have united with the Established Church and their annual General Assembly convenes here. A statue of Robert Knox in the quadrangle oversees proceedings!

During construction of the new Scottish Parliament building at Holyrood between 1999 and 2004, the debating chamber was used by MSPs as a temporary home.

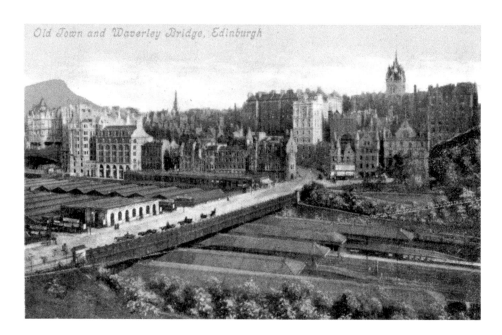

Old Town and Waverley Bridge

The view from this angle illustrates the lofty heights attained by the tenements of Old Town; as the population grew, so another level was added to accommodate it. The restricted space within the city walls dictated that the only way was up!

The foreground hollow was once full of the polluted water of Nor' Loch, but this was drained away in 1759 as part of the proposals to improve Edinburgh. Crucial to these plans was the decision to create a New Town on the northern side of the valley as the city was, by this time, literally bursting at the seams. The first structure to connect the two was North Bridge, one arch of which can be seen on the left. Later the cross-valley route of The Mound was built up, but Waverley Bridge was constructed in 1894 specifically to give access to the railway station.

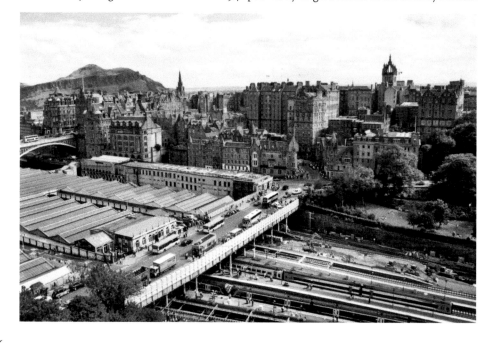

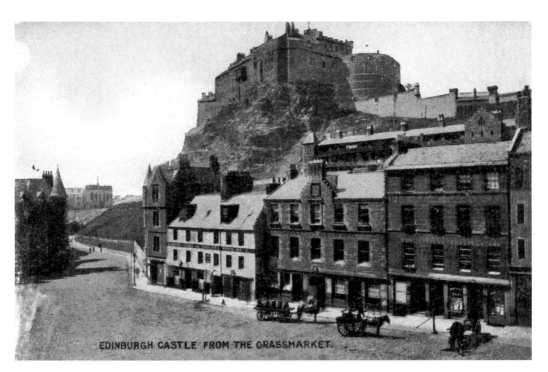

EDINBURGH CASTLE FROM THE GRASSMARKET.

Edinburgh Castle from Grassmarket
In the declivity below the southern face of Castle Rock is the rectangle of The Grassmarket. In medieval times it was a populated suburb outside the city walls, but after the Battle of Flodden in 1513, further defences were put up (the Flodden Wall) which enclosed it. The West Port (entrance) into the area was at the south-western corner, but all trace of these gates has long since disappeared.

At the diagonally opposite corner, the steep, narrow and winding lane of West Bow led to Lawnmarket. The closeness of the house frontages, often with wooden gables jutting out, made it a dark, but atmospheric, place and some notable tales have been told of it. One such concerned a strange character called Major Weir who always wore a dark cape and carried a black staff, which purportedly ran in front of him under its own steam!

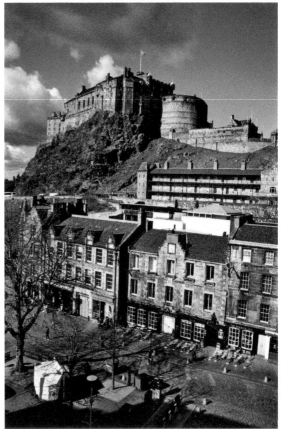

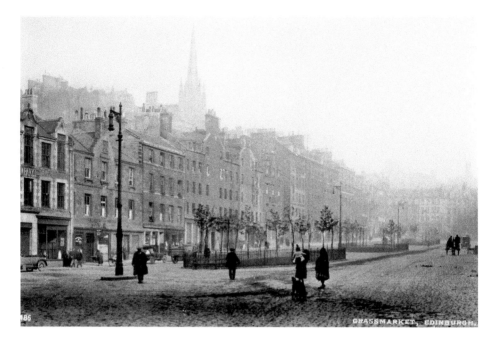

The Grassmarket

The Grassmarket was always a lively place, particularly when executions took place. Wretched prisoners were brought from the stinking Old Tolbooth, followed by crowds of onlookers, and sometimes riots ensued. It was also the venue for livestock and produce markets; corn markets in fact only ceased in 1912.

Contemporary Grassmarket has utilised the spacious market area by restricting traffic flow, allowing bars and cafés to set tables outside, similar to a European piazza. To remind us of more brutal times,a gibbet shape has been laid in the pavement next to the memorial to The Covenanters, many of whom were killed by it.

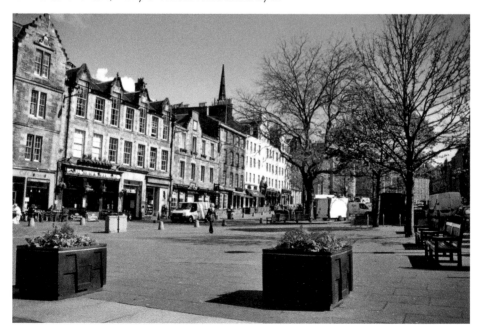

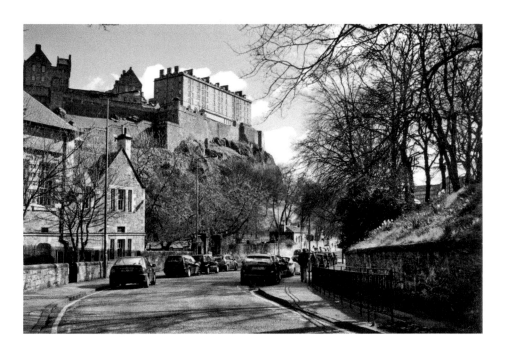

Castle from Kingstables Road

This thoroughfare, leading into The Grassmarket from the west, edged the southern bank of Nor' Loch, on which were gardens, orchards, stables and a farm for royal use. When Johnstone Terrace was made in 1827, the King's Bridge, adorned by obelisks at each side, was constructed to cross this road.

The circular watchtower at the road's entrance belongs to St Cuthbert's church and graveyard, which both lie below street level. These lookout posts were required by churches in order to guard against theft of bodies during the early nineteenth century, when dissection of cadavers was used to teach anatomy to medical students at Edinburgh University. The notorious case of Burke and Hare still captures the public imagination.

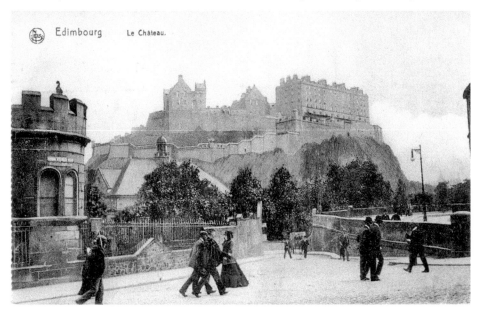

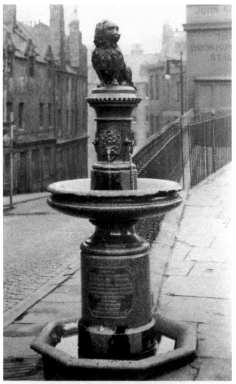

GREYFRIARS BOBBY. EDINBURGH
THE DOG WHICH WOULD NOT LEAVE HIS MASTER'S GRAVE
STATUE ERECTED BY THE BARONESS BURDETT COUTTS
SUTHERLAND

Greyfriars Bobby

The story of this terrier is universally known and loved; the facts have been distorted over time, but the sentiment is correct. The life-size statue and fountain were put up in 1872, and the granite basin at its foot was presumably for canine refreshment! The inn named after the dog is situated at the top of Candlemaker Row, a steep hill down to the Grassmarket. Behind them sits Greyfriars church, in whose graveyard rest many Edinburgh luminaries. It became the replacement burial ground for that of St Giles, which was full by 1562, so Queen Mary offered the garden of Greyfriars monastery for the purpose.

After the Reformation in the sixteenth century, Greyfriars church was the first to install a window of stained glass, a practice which had been forbidden.

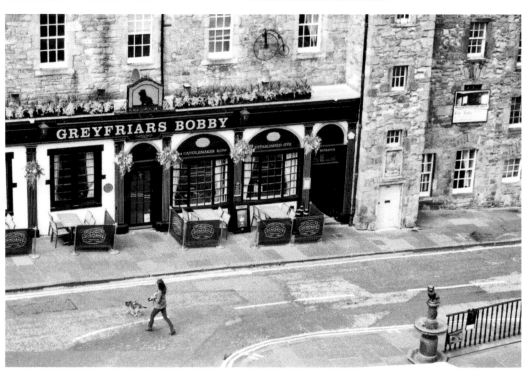

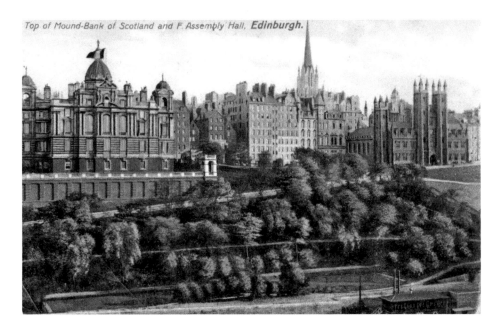

Bank of Scotland

Banking is a traditional business of Edinburgh. The Bank of Scotland was formed in 1695, operating from a close in Old Town, and was the first bank in Europe to issue notes. The monopoly ended when Royal Bank of Scotland set up in 1727. Great rivalry ensued between them, particularly regarding the prestigious locations chosen for their premises. The commanding site picked by the Bank of Scotland in 1801 ensured that it was visible to all from the New Town.

By 1825, Royal Bank of Scotland had established itself in a detached mansion in St Andrew Square, one of the original properties of the New Town, built in 1771 for Sir Laurence Dundas.

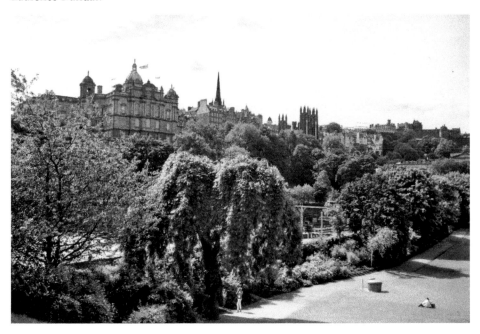

21

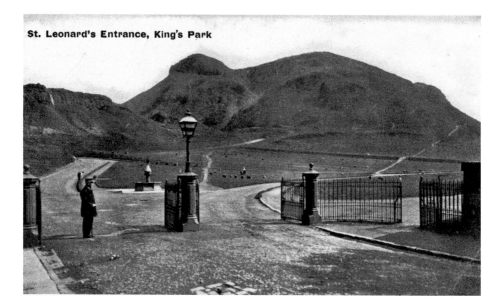

St. Leonard's Entrance, King's Park

St Leonards

St Leonards is situated on elevated ground overlooking Holyrood Park and Salisbury Crags. In 1831, Edinburgh's first railway terminated here to supply the city with coal from the mining villages to the south, although it closed in 1846 when North British Railway built the central Waverley station. It was known as Innocent Railway, due to a good safety record. The disused trackbed now functions as a cycle route.

Publisher Thomas Nelson owned a large printing works on the site where Scottish Widows and Royal Commonwealth Pool now sit, but the local housing had dilapidated so much by the 1950s that the slums were cleared away for redevelopment.

The land in Holyrood Park was used for allotments during the Second World War, and sheep grazed the slopes as late as 1977.

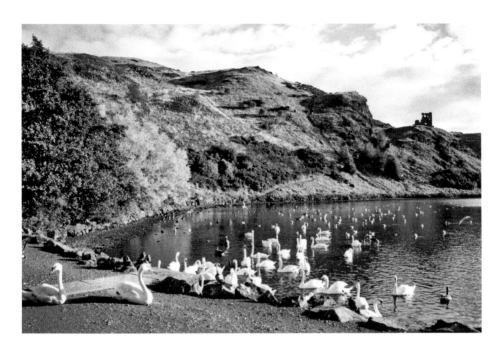

St Margaret's Loch and St Anthony's Chapel

James V, in 1541, enclosed Arthur's Seat and Salisbury Crags as a royal park for the newly built Palace of Holyroodhouse. Influence from the monarchy continued, particularly during the reign of Queen Victoria, when Prince Albert decided that Queen's Drive was to be created around the park together with the lochs of St Margaret and Dunsapie. The former was used as a boating pond but nowadays it is swans, geese and wildfowl that grace the water.

The history of St Anthony's chapel is sketchy, although it is thought to have been in use in the fifteenth century and probably fell into disrepair after the Reformation of 1560.

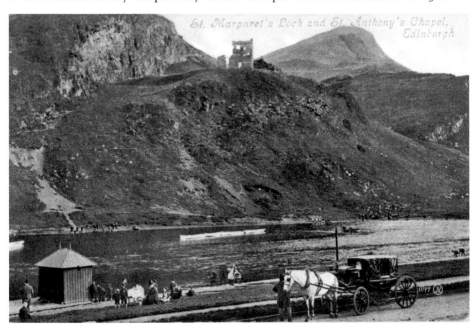

St. Margaret's Loch and St. Anthony's Chapel, Edinburgh

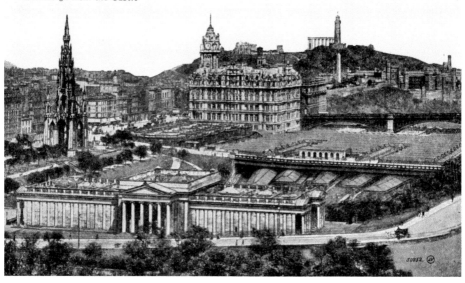

Edinburgh from the Castle

The panoramas of Edinburgh's hinterland seen from the castle underline its suitability as a defensive location, helped by the barrier of Nor' Loch, which filled this valley until 1759. The North Bride was the first to span the hollow after it was drained. Then, as earth and rubble was generated during the construction of the New Town and deposited in the centre of the valley, it was realised that another crossing between Old and New could be possible; the result is the slope known as The Mound. The large, Grecian structures at the foot – the Royal Scottish Academy of 1826 and, behind it, the National Gallery of 1854, both designed by William Playfair – are splendid landmarks at the very heart of modern Edinburgh, joined by a subterranean restaurant and café complex.

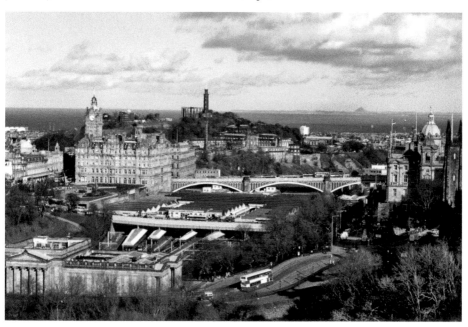

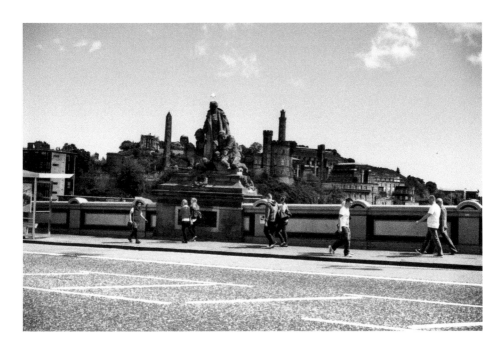

North Bridge

In 1763, the architect William Mylne designed a triple-arched bridge to span the eastern end of the hollow left by the drained Nor' Loch, joining Lawnmarket to Bearford's Park, the moorland on which construction of the New Town was proposed. The prototype partially collapsed at the northern end after only a few years but was rebuilt successfully and survived until it was widened and redeveloped between 1894 and 1897 and strengthened with steel girders.

The memorial to the King's Own Scottish Borderers commemorates those who died during the South African campaigns of 1900 and 1902. The regiment has recently been merged with the Royal Scots.

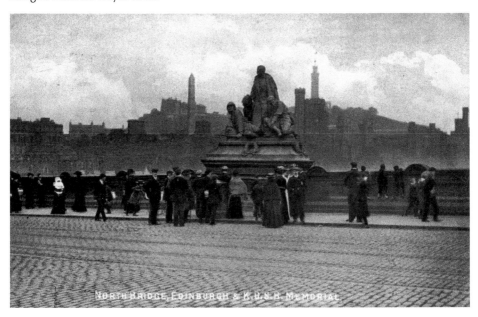

NORTH BRIDGE, EDINBURGH & K.O.S.B. MEMORIAL.

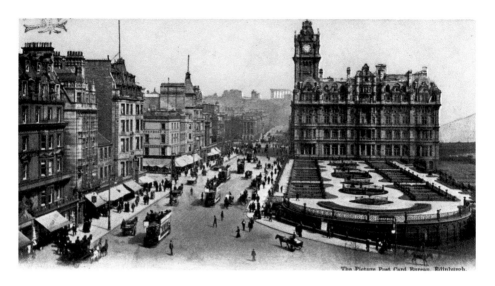

The Picture Post Card Bureau. Edinburgh.

North British Hotel, Princes Street

Register House is built on land which was known as Multree Hill, facing the northern exit of North Bridge, whose owner could only be induced to sell the plot with the enticement of being given alternative space below the bridge. Meanwhile, the development of Princes Street, with its stunning view across to Old Town, was proving so popular with Edinburgh citizens that new proposals to develop the opposite side of the street were greeted with horror. The issue ultimately went to the House of Lords, who thankfully prevented it. The aforementioned landowner was allowed to develop his site with the proviso that no buildings rose above street level. It became Waverley Market, now a modern shopping arcade with a landscaped seating area on the roof.

The distinctive Victorian North British Hotel – now The Balmoral – dates from 1895, when rail travel was at its height. The large clock is said to be three minutes fast, to help those who are hurrying to catch a train from Waverley station.

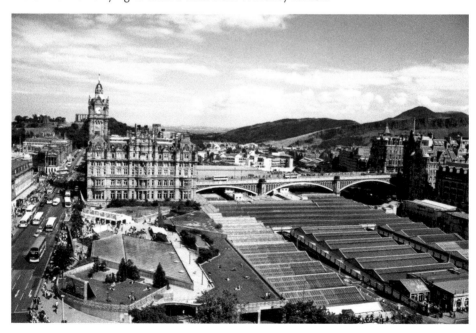

Scott Monument

Sir Walter Scott was one of Scotland's greatest novelists, so, after his death in 1732, a competition was held to design a monument to commemorate the man and his work. The winner was George Meikle Kemp, a self-taught draughtsman and architect who submitted his entry under the pseudonym John Morvo. Sadly, he did not survive to attend the inauguration of his 200-foot Gothic structure, as he drowned in the Union Canal one foggy night while walking home.

The memorial – the largest in the world to a writer – is built of stone from Binny Quarry in West Lothian with the sculptures of Scott and his dog, Maida, carved out of Carrara marble. Sixty-four small, carved figures representing characters from his novels are placed throughout.

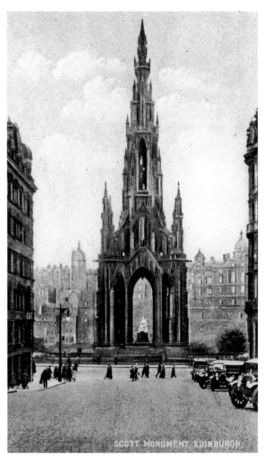

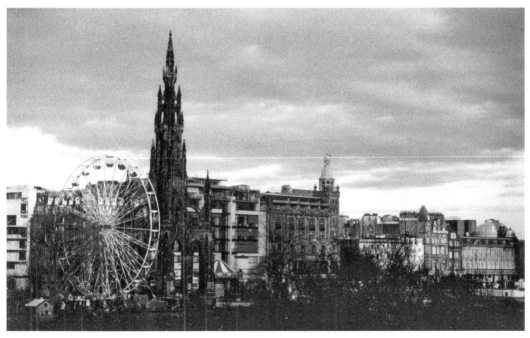

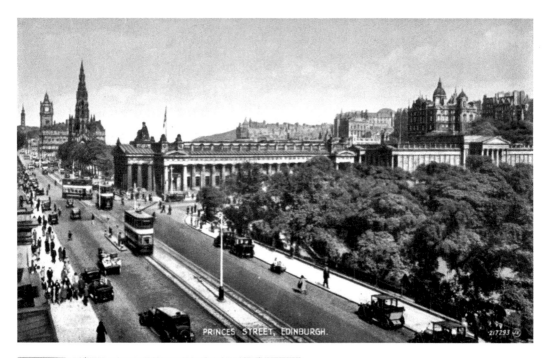

PRINCES STREET, EDINBURGH.

Princes Street from Mackie's Tearoom

The spacious promenade of Princes Street is well served by coffee shops and restaurants but one particularly beloved of Edinburgh people was Mackie's Tearoom. The elevated location on the first floor enhanced the already stunning view across the gardens to the castle and the cluttered skyline of Old Town while partaking of tea and scones. They advertised themselves as 'Purveyors of Rusks and Shortbread to late King George V'.

In 1897, horse-drawn trams were replaced by cable cars which in turn were superseded by electric trams in 1922, before all being swept away by the automobile. However, history is repeating itself with the imminent introduction of trams in central Edinburgh, albeit at great cost and much controversy.

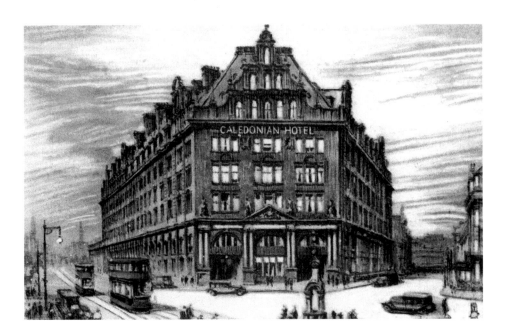

Caledonian Hotel, Lothian Road

The fact that Princes Street is punctuated at either end by imposing hotels is down to the intense competition between railway companies in the Victorian era. The Caledonian Railway station, terminus of the line from Glasgow, was situated at the bottom of Lothian Road and the bulky, red sandstone edifice was built around the platforms so that the main entrance led to the station as well as the hotel. Rail operations terminated in 1965 when all traffic went to Waverley.

The disused goods yards covered a large tract of ground which has since been redeveloped and populated with a variety of modern buildings, mostly financial establishments, an international conference centre and a by-pass known as the Western Approach Road.

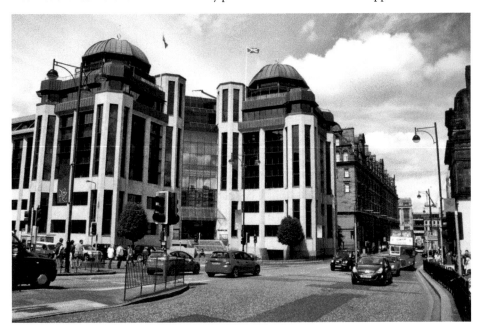

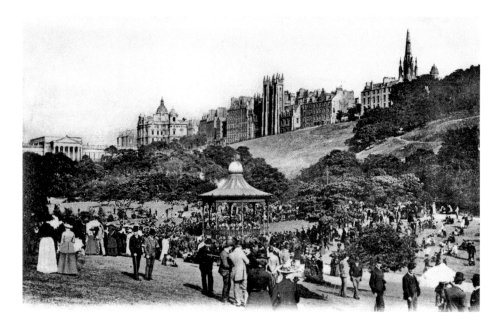

West Princes Street Gardens

Standing at this point two and a half centuries ago would have been an assault on the senses! The brackish water of Nor' Loch, polluted by all kinds of waste, would have given off an unbearable stench and the ground would have been a dark, squelchy quagmire. The knowledge that witches had been drowned here in the sixteenth and seventeenth centuries could only have added to the sinister atmosphere.

Once the eighteenth-century improvements began, the gardens began to flourish, but until 1876 they were considered private, and entrance could only be gained for a fee. Today, they add aesthetic beauty to the centre of the city, providing an oasis of calm between the High Street and bustling Princes Street.

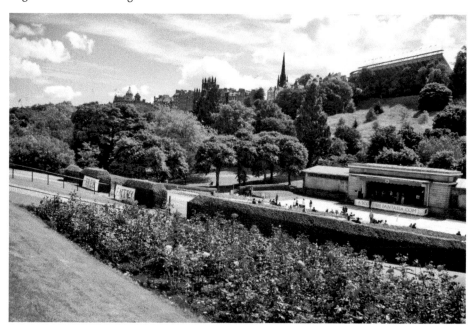

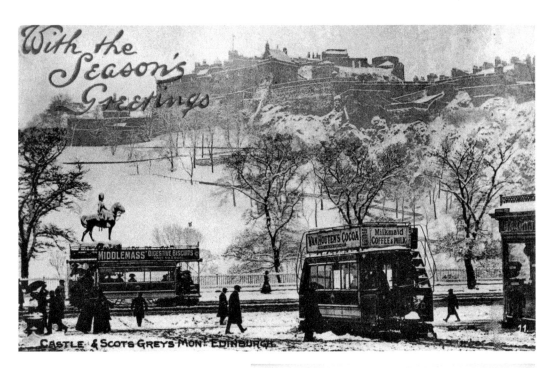

With the Season's Greetings

CASTLE & SCOTS GREYS MON. EDINBURGH

Royal Scots Greys Memorial
Edinburgh has a wealth of statues, emphasising its status as capital of Scotland, and the practice became particularly fashionable once the New Town had been developed. The northern edge of Princes Street Gardens is lined with memorials, including those to James Young Simpson, David Livingstone and Thomas Guthrie.

The bronze man on horseback, sculpted by William Birnie Rhind, depicts a Royal Scots Grey soldier and commemorates those in the regiment who died during the Second Boer War of 1899. It was unveiled in 1906 by Lord Rosebery.

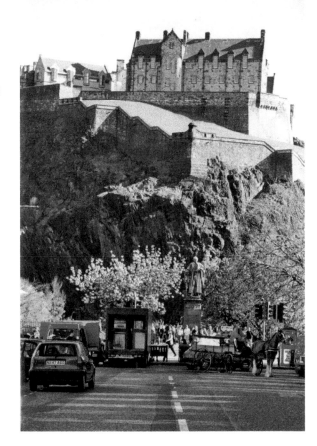

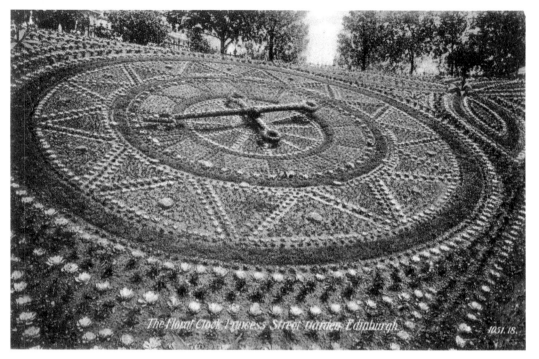

The Floral Clock Princess Street Garden, Edinburgh

1051.18.

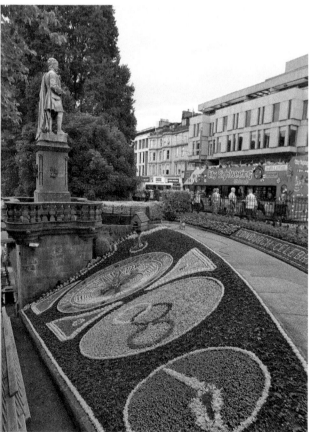

Floral Clock

By 1903, Princes Street Gardens were established as a public amenity and gardeners were employed full-time to tend them. The superintendent at that time was an innovative man called John McHattie, who came up with the idea of a floral clock. The first year's attempt only had an hour hand; the operating mechanism, hidden inside the nearby statue of Allan Ramsay, had been salvaged from Elie church and needed winding up every day. However, it captured the imagination of the public, not just locally, but worldwide and has been copied many times over. The addition of a cuckoo clock dates from 1953.

Calton Hill from Waterloo Place

This modest, 355-foot plug of volcanic rock, just beyond the east end of Princes Street, has on it a remarkable number of disparate structures for its size, namely, Observatory House of 1776, Playfair's City Observatory, Nelson's Monument, Dugald Stewart's Memorial and the unfinished National Monument. The architecture of the latter two reflects the era of Greek Revival and contributed to Edinburgh's sobriquet 'Athens of the North' in the early nineteenth century. A steep street, also called Calton Hill, ran down to Leith Street and houses from 1760 are still inhabited there.

In 1815, the scruffy tenements of Shakespeare Square, together with the beloved Theatre Royal, were cleared away to be replaced with the elegant terrace of Waterloo Place.

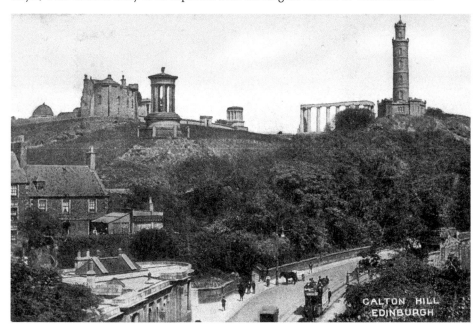

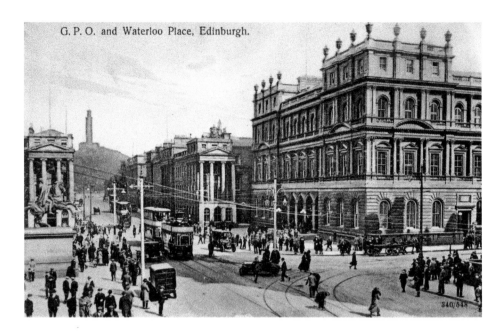

G. P. O. and Waterloo Place, Edinburgh.

General Post Office, Waterloo Place

The junction at the east end of Princes Street with North Bridge has attracted large and prestigious buildings. The first Register House (1774) stood proud, facing the route over North Bridge; the bronze statue of the Duke of Wellington on horseback was erected in front of it in 1848, created by sculptor John Steell, whose work also included Walter Scott. Then, during the Victorian era, both the General Post Office (1861) on the eastern corner and the North British Hotel (1902), primly staring at it from the opposite corner, became landmarks of the city.

The grand façade of the old GPO premises is at odds with its current status. The Post Office vacated the building in 1995, then in 2003, £100 million was spent redeveloping it – renamed Waverley Gate – but at the end of that decade, the building was virtually empty.

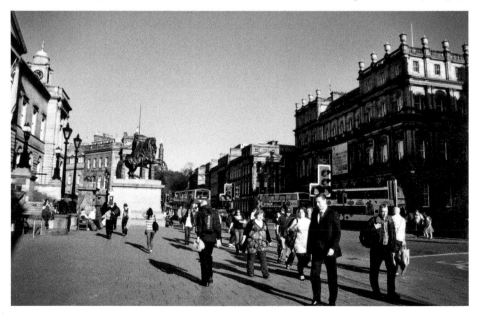

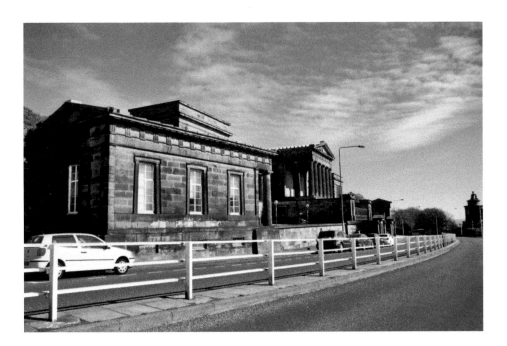

Royal High School

Below the south-facing crag of Calton Hill is the neoclassical Royal High School, a splendid example of Greek Revival architecture, designed by Thomas Hamilton. Finished in 1825, it replaced the overcrowded Royal High School in Old Town's Infirmary Street and was used up until 1968, when pupils were relocated to more modern premises at Barnton.

Shortly after this, support for the Scottish National Party increased, culminating in a referendum about independence for Scotland. If the vote had gone their way, the Scottish Assembly planned to use the main hall of the school as a debating chamber. The venue was considered again in 1997 after devolution for Scotland, but the Scottish Parliament opted instead for the expensive – £414 million – and controversial new design at Holyrood.

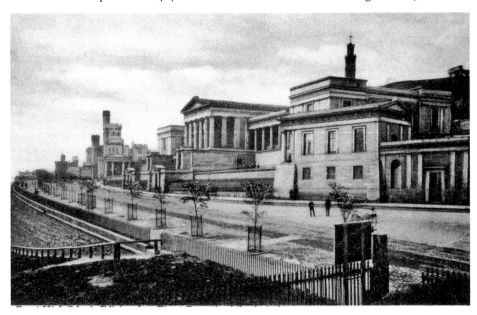

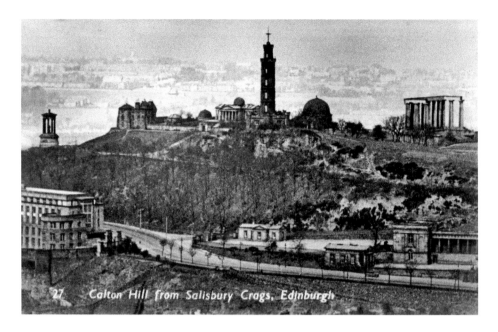

27 Calton Hill from Salisbury Crags, Edinburgh

Scottish Parliament Building

Old and new sit jumbled together between the elevations of Salisbury Crags and Calton Hill. The Scottish Parliament, designed by the late Enric Miralles, opened in 2004 and now dominates this part of Canongate. The seventeenth-century mansion of Queensberry House has been incorporated into the overall plan; fifty years before that was built – in 1640 – the first Parliament House was completed behind St Giles Cathedral thanks to Charles I, who considered the Tolbooth a wholly inadequate meeting place in which to make the laws of the land. Then, in 1707, came the Treaty of Union with England, and Westminster, rather than Edinburgh, was where parliament met. The next few years may see a reversal of this situation.

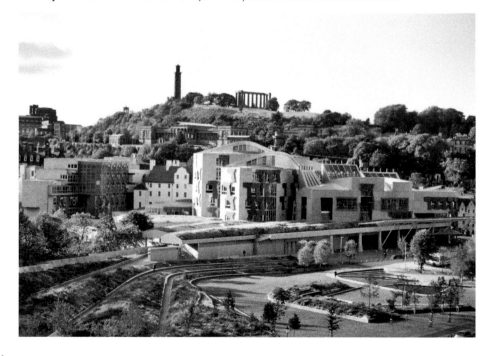

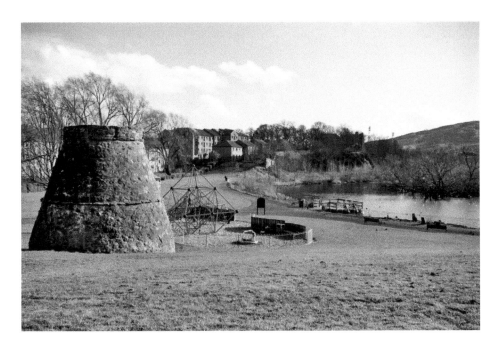

Lochend

The farmland of Restalrig stretched between Arthur's Seat and Leith and was overlooked by Lochend Castle, a tower house perched on a crag above the loch and owned by the Logans of Restalrig. That fortification was largely destroyed in the late sixteenth century, but in 1820 its remains were incorporated into Lochend House. This property is now uninhabited but utilised by Edinburgh Council as a day centre for children. The beehive doocot (sixteenth century) has survived the passage of time.

The loch is greatly reduced in size and has been surrounded by a fence, but is the central feature of Lochend Park. Restalrig remained a rural area until the 1920s, but since then has been heavily built up.

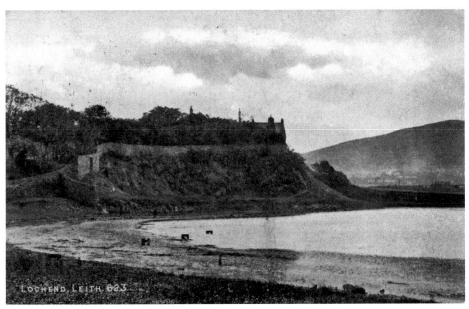

37

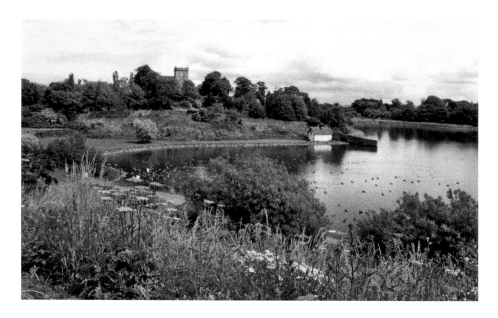

Duddingston Loch

Duddingston is discreetly tucked away below Dunsapie Crag, just outside the perimeter of Holyrood Park. The silhouette of its church tower is a picturesque backdrop to the loch; although the exterior is seventeenth-century, the innermost heart of the church is Norman.

The loch was the meeting place of Edinburgh Skating Club, the first of its kind, founded in 1742, and the pastime has been immortalised by Sir Henry Raeburn's painting of 1790, *The Reverend Robert Walker Skating on Duddingston Loch*, which hangs in the National Gallery of Scotland.

It is rare now for the water to be frozen but the reed beds in the south of the loch, known as Bawsinch Reserve, attract a wide range of birds and their watchers.

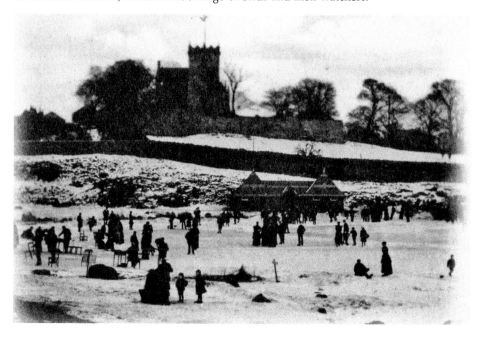

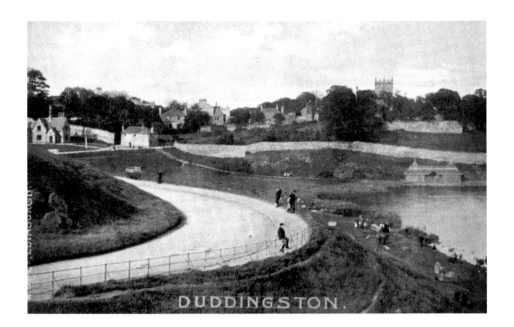

Duddingston village

This was an industrious little community throughout the seventeenth and eighteenth centuries, mainly due to salt and coal mining, but weaving too was important and the village was known for a particular cloth called Duddingston Hardings.

A quiet, cobbled walkway leads from the loch to the main street – the Causeway – on the corner of which is a pub called The Sheep Heid, purportedly the oldest in Scotland. Mary, Queen of Scots used this hostelry when travelling between Holyrood Palace and Craigmillar Castle and her son, James VI, gave the innkeeper a snuff box decorated with a ram's head.

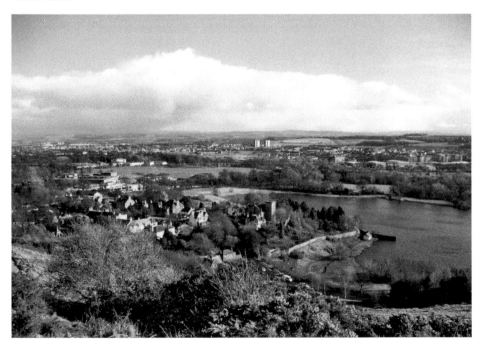

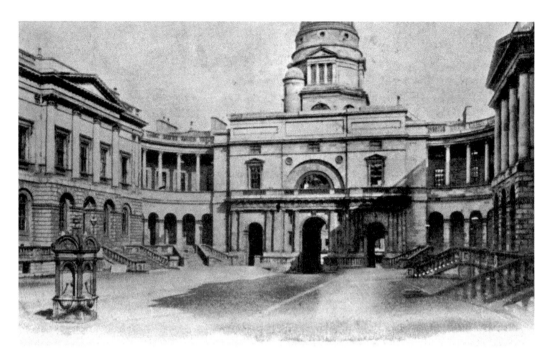

Edinburgh University

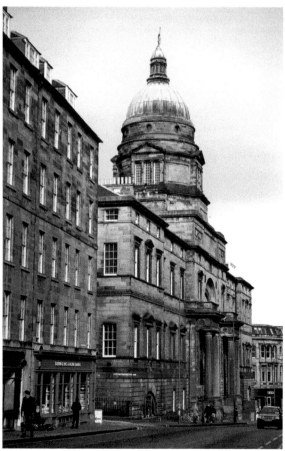

The site on which the Old College was built was known as Kirk O' Field, a place etched into Edinburgh's history, as it was here where Lord Darnley, husband to Mary, Queen of Scots, was murdered in 1567.

A charter was granted to the Town Council by James VI in 1583 for provision of a college to teach, among other humanities, theology, which was thought crucial after the Reformation.

Students and professors alike made do with the old ecclesiastical buildings until the second part of the eighteenth century, when the Scottish Enlightenment precipitated great improvements to the city. North Bridge was extended to cross Cowgate, creating South Bridge and opening up a thoroughfare, along which the monumental façade fronts the Old Quadrangle of Edinburgh University. The complex was completed by 1820, over thirty years after the first stone was laid.

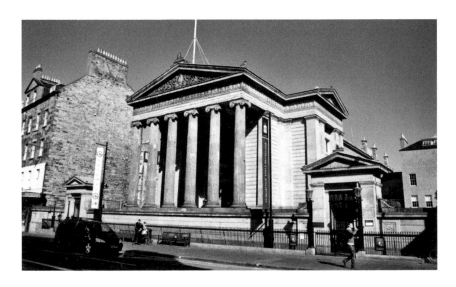

Surgeons' Hall

The Royal College of Surgeons dates back as far as 1505 when it was associated with barbers, a situation that the medical men increasing tried to rectify, though not successfully until 1722, by which time, the first Chair of Anatomy had been created. In 1697 Surgeons' Hall was built in Surgeons' Square, which housed a library and dissection room, but, in order to teach, a regular supply of bodies was required. Dr Robert Knox (1791–1862), a surgical pioneer of his day, became involved with the notorious William Burke and William Hare, causing his fall from grace and an enduring story!

Today's Surgeons' Hall, opposite the Old College (both of which were designed by Playfair) was built in 1829 and opened to the public three years later. The museum is home to a fascinating array of pathological specimens and terrifying instruments. It is sobering to think that James Young Simpson did not discover anaesthetic until 1847.

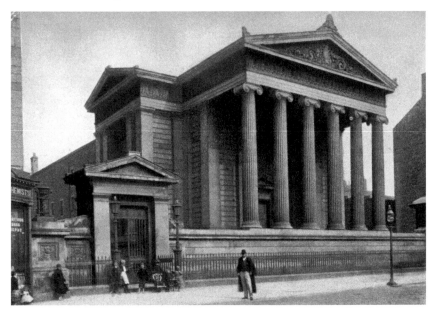

Royal Infirmary from The Meadows

The land to the south of Old Town dipped to the Burgh Loch (or South Loch) before rising to the moorland of Burgh Muir. This source of water was outside the town walls and, as such, not so prone to pollution as the Nor' Loch so it was used for the town's drinking water until water could be piped from Comiston Springs in 1621. Completely drained in the eighteenth century, it created the large public space of The Meadows, which has been used variously for livestock grazing and markets, exhibitions, allotments, sport and rallies but not as a racecourse, which was once proposed.

The northern fringe of The Meadows is lined with the Victorian buildings of the Royal Infirmary. Originally in Old Town as a hospital for the sick poor, starting life in Robertson's Close, then in Infirmary Street, it moved to Lauriston Place in 1879 until this, too, was outmoded and a modern royal infirmary opened in 2002 at Little France. The Quarter Mile project is converting the premises into luxury apartments.

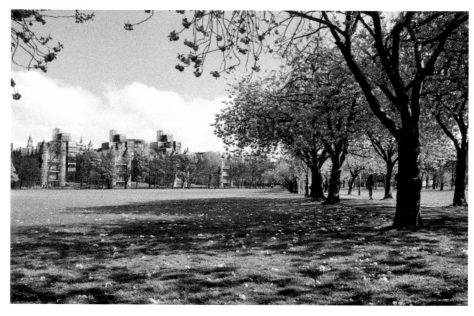

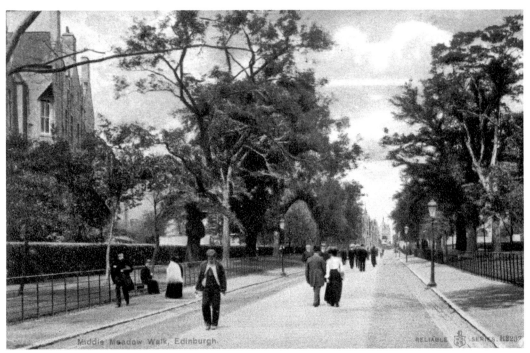

Middle Meadow Walk, Edinburgh.

RELIABLE SERIES. R2287

Middle Meadow Walk

The wide walkway between the Royal Infirmary and University Medical School, goes due south across The Meadows to the Victorian tenements of Marchmont, which were built on Burgh Muir.

Behind the eastern wall of Middle Meadow Walk is George Square, a quiet, cobbled rectangle with a central wooded garden. This was the first development to the south of Old Town – started in 1776 – and modest in comparison to James Craig's ambitious plan for the New Town. The houses were considered highly desirable because, by this time, the High Street was chronically overcrowded and filthy.

Unfortunately, the present-day square, while retaining the verdant heart, is an architectural admixture of harsh, contemporary blocks and residual eighteenth-century houses.

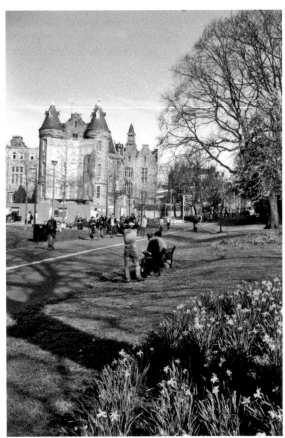

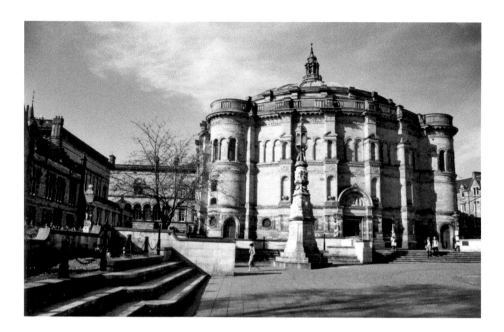

McEwan Hall

The curved frontage of this D-plan building adjoins the university medical school. It is crowned by a shallow, ribbed dome, affectionately described as a 'petrified blancmange' (*The Buildings of Scotland – Edinburgh*, 1984).

The Teviot Place buildings were constructed between 1876 and 1886 but there was insufficient money for the planned graduation hall, until the philanthropic brewery owner and politician William McEwan offered to pay for one. The interior design emulated a Greek Theatre, both acoustically and decoratively; murals of goddesses representing art, science and literature adorn the dome and Temple of Fame. Two semi-circular galleries maximise the seating capacity, which is 2,000.

The ornate hall was completed by 1897 and used for public events and concerts as well as graduations, but a rival brewer paid for the Usher Hall to be built in 1914, which became the venue of choice thereafter.

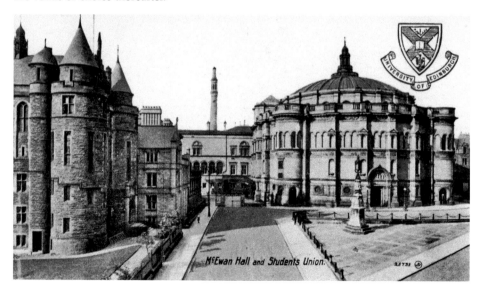

McEwan Hall and Students Union.

The Dick Vet

The history of the Royal Dick School of Veterinary Studies began in a modest Clyde Street building, long since demolished and replaced by a bus station. William Dick, veterinary surgeon to Victoria, taught veterinary students in the above premises and by 1833 had added a lecture theatre, dissecting room, animal hospital and museum. William Dick died in 1866 but his veterinary college was left to the Burgh Council and continued in Clyde Street until 1916, when it moved to Summerhall, where the row of cottages and United Presbyterian church were cleared away to accommodate the neoclassical Dick Vet, as it became known.

The veterinary school has been part of Edinburgh University since 1951 and has recently relocated to Easter Bush Campus.

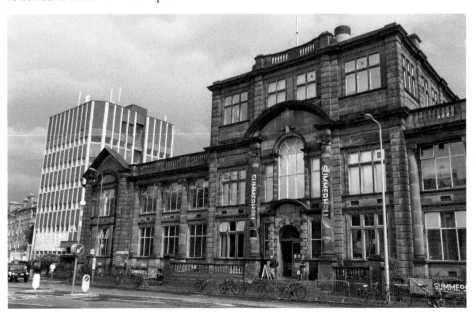

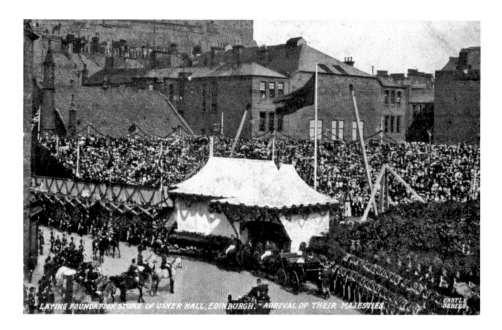

LAYING FOUNDATION STONE OF USHER HALL, EDINBURGH. - ARRIVAL OF THEIR MAJESTIES.

Usher Hall

The motivation of the wealthy brewery-owner, Andrew Usher, to pay for the creation of a concert hall may not have been entirely altruistic! His arch-rival, the owner of McEwans brewery, had just acted as benefactor for Edinburgh University's graduation hall, in which musical events were also performed. Nearby George Square was considered but ultimately the Usher Hall was built on Lothian Road. Completed in 1914, it fulfilled its role as a first-rate concert hall, and still does.

The superb acoustics are widely praised, not least by the musicians performing at the annual International Festival, for which Edinburgh is so well known.

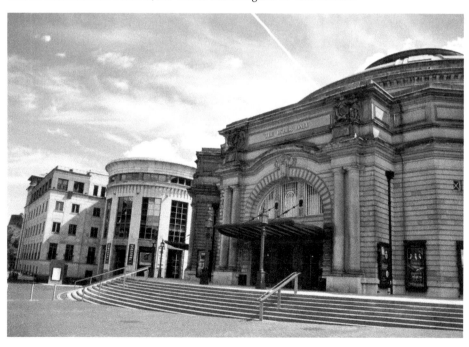

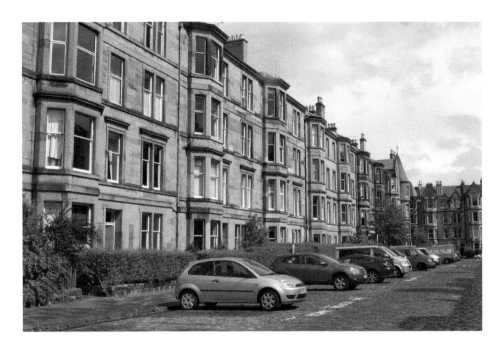

Thirlestane Road

The Southern expansion of Edinburgh took the form of stone-built tenement rows, often with bay windows, lining both sides of wide, cobbled streets. The land this side of The Meadows was largely owned by Sir George Warrender, who lived in the sixteenth-century Bruntsfield House on the Burgh Muir. He feued plots of land on his estate to builders but requested that the streets were named after himself or places in Berwickshire, where other branches of the family had estates – hence Thirlestane and Marchmont. The latter name has been adopted for the whole district since 1914.

The idiosyncratic Warrender Baths of 1887 – now called Warrender Swim Centre – in Thirlstane Road have managed to retain a Victorian ambience.

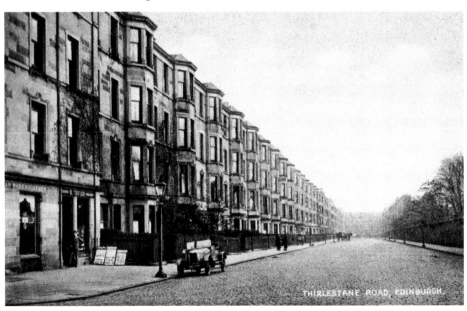

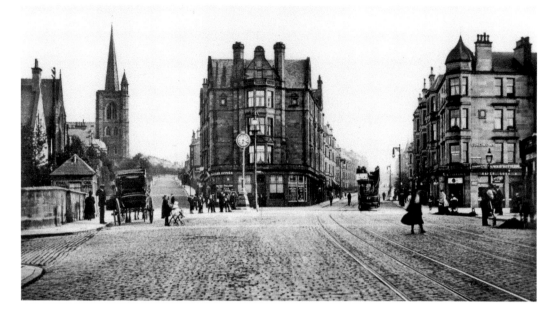

Morningside Clock

The ridge of Burgh Muir drops down to the Jordan Burn valley, and along this slope, with the backdrop of the Pentland Hills, Victorian villas and tenements formed the district of Morningside. This respectable suburb was served by a railway station between 1884 and 1962, after which, passenger traffic was withdrawn from Edinburgh's suburban rail network – a casualty of the Beeching axe. The clock was for the benefit of railway travellers and was in the centre of the road junction, but now resides on the pavement nearby. The station itself was converted to shops but a vestige of that era is the iron footbridge crossing the line between Balcarres Street and Maxwell Street.

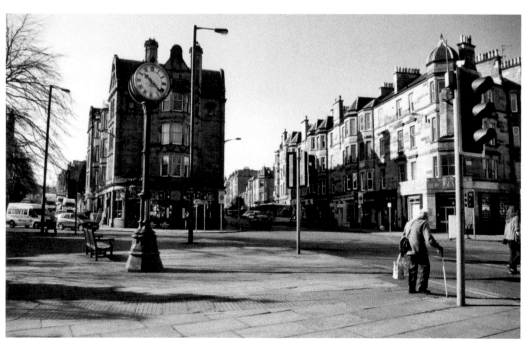

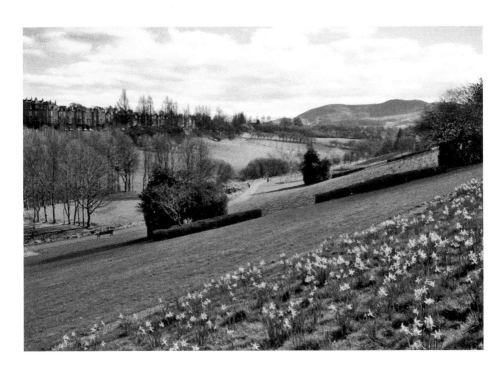

Braid Burn

Comiston was important to the Old Town of Edinburgh, not only for crops grown on the farmland but also for its water. By the seventeenth century the Old Town struggled to obtain sufficient fresh water for the growing population and the nearby Nor' Loch was extremely polluted, so, in 1672, the council began to install five well-heads at different locations within the town and lay pipes to Comiston, from whose springs the precious resource could be drawn. Pipe marker stones are still visible in Braid Burn Park, the name given to this valley by Edinburgh Corporation when they purchased it in 1933 and created an important public amenity.

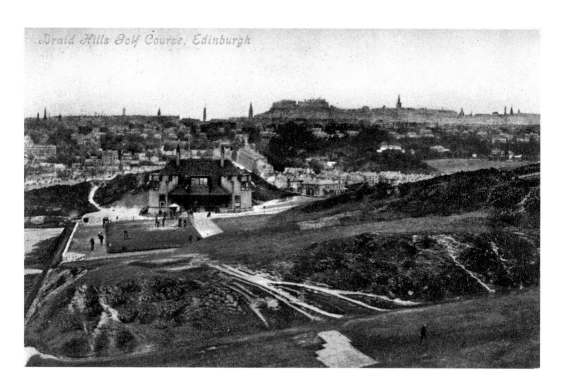

Braid Hills Golf Course, Edinburgh

Braid Hills Golf Course

This municipal golf course was first laid out in 1893 on the heathland of Braid Hills, on the southern fringe of the city. The panoramas from the course are unparalleled all year round and embellished with vibrant golden gorse bushes in spring. The attractive red-roofed building in both pictures was built by the Edinburgh Corporation in 1897; there was living accommodation at either end for the superintendent and green keeper and a pro-shop in between.

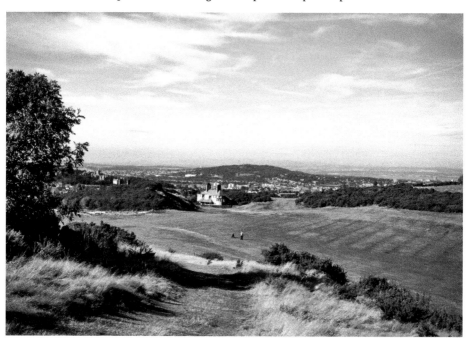

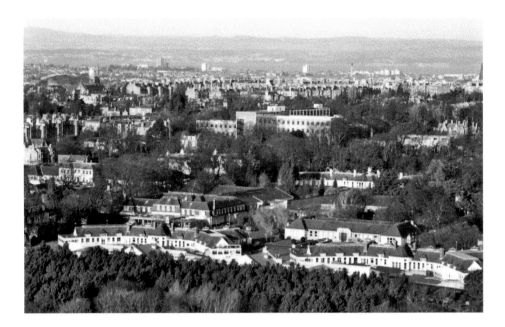

Astley Ainslie Hospital

This land on which this hospital now stands was part of Burgh Muir, the mustering point for the Scottish troops in 1513 before marching to the disaster that was Flodden. At that time, the chapel of St Roque was situated nearby, whose burial ground held many victims of the plague. It was demolished in 1791.

David Ainslie, of Costerton, who died in 1900, allocated money in his will for the provision of a convalescent hospital for patients leaving the Royal Infirmary. The chosen location included four villas and a nine-hole golf course but the completed complex, finished by 1930, utilised the existing houses for administration and the gardens provided a therapeutic environment to aid recovery. It specialises in rehabilitation after strokes, cardiovascular events and brain injuries.

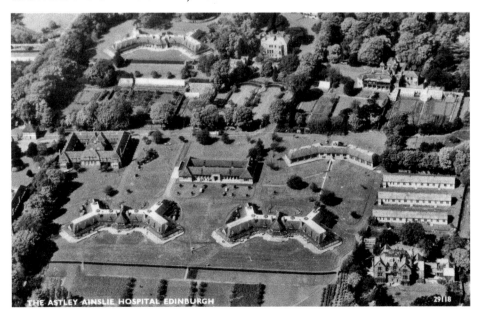

THE ASTLEY AINSLIE HOSPITAL EDINBURGH 29118

51

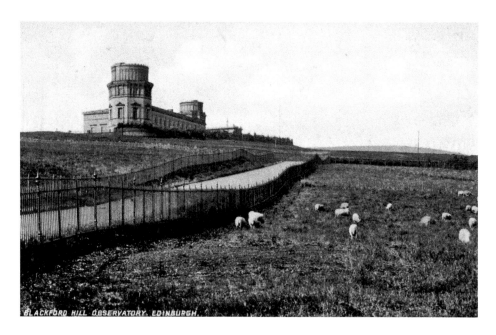

BLACKFORD HILL OBSERVATORY, EDINBURGH.

Blackford Hill Observatory

The vantage point of Blackford Hill has been used over the centuries for artists to produce engravings of the view over Edinburgh. Considerably longer distances were envisaged when the new observatory was opened here in 1896, to replace the one on Calton Hill which, although popular, had difficult access and insufficient space. In fact, there was a proposal to close it as a National Institution and gift it to Edinburgh University, but the situation was resolved when Aberdeenshire benefactor, The Earl of Crawford, offered the contents of his own observatory and library, at Dunecht, to the nation. The gesture precipitated the decision by the government to build Blackford Hill Observatory.

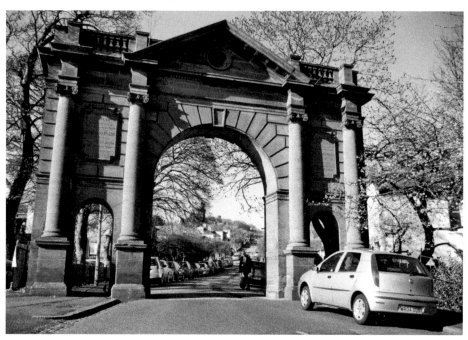

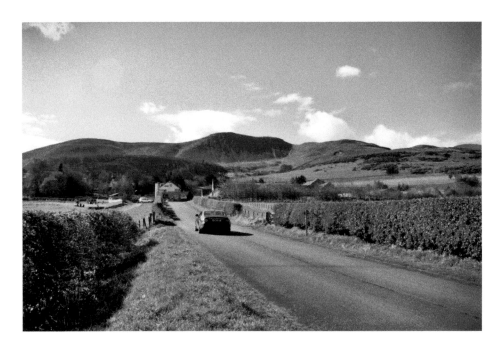

Horses near Swanston

A pastoral scene like this would have been familiar to Robert Louis Stevenson, whose father rented Swanston Cottage each summer between 1867 and 1880. The simple thatched cottage, together with filter beds, had been built in 1761 by the town council as the place from which a second water supply could be drawn; Comiston Springs was proving insufficient for the expanding city. The property was radically extended in 1835 to create the smart house seen today.

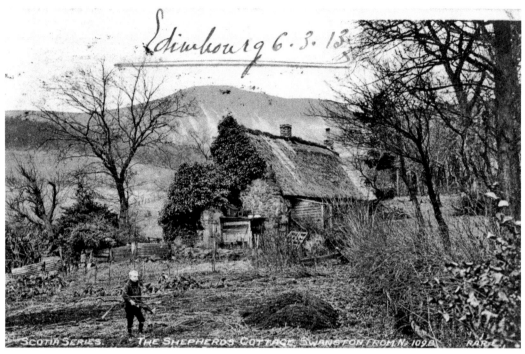

Edinbourg 6·3·13

SCOTIA SERIES. "THE SHEPHERDS COTTAGE SWANSTON FROM N. 1098 RARE.

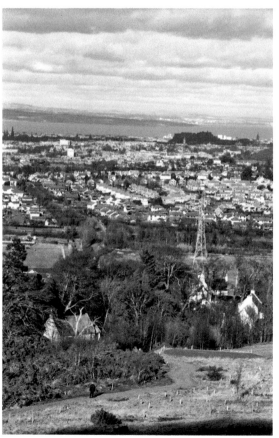

Shepherd's Cottage, Swanston
The cluster of thatched cottages for farm labourers dates from the early eighteenth century and despite local water being piped to the city, the properties themselves did not benefit from the improvement until the 1930s. The once isolated hamlet drew closer to city boundaries during the twentieth century as the rash of modern bungalows filled the view to the north, followed by the construction of the Edinburgh Bypass, laced with electric pylons, shearing through the valley below. It is still possible to capture some aesthetic rustic charm, albeit with a background roar of traffic.

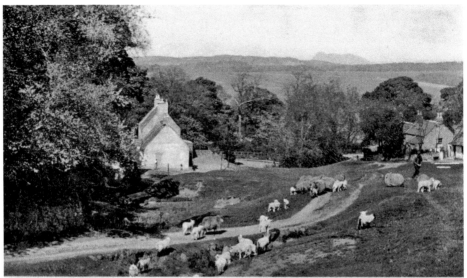

SPRING TIME AT SWANSTON — JAMES PATRICK

"A stilly hamlet home that vies
With any earthly paradise."—R.L.S.

Springtime at Swanston

In the 1960s, Edinburgh Council took the decision to restore the ten deteriorating cottages in Swanston and converted them into seven picturesque dwellings, some with thatched roofs, using material from reed beds in the Tay estuary.

Swanston Farm, lower down beyond the trees, is also eighteenth-century – with later outbuildings – and currently runs a thriving livery business. Also, two golf courses are laid in the environs; Lothianburn to the east and Swanston next to the village. The latter has recently built a large clubhouse complex, whose restaurant serves meat and produce from the farm. Swanston village, having almost died, has been reborn and lives comfortably within Pentland Hills Regional Park.

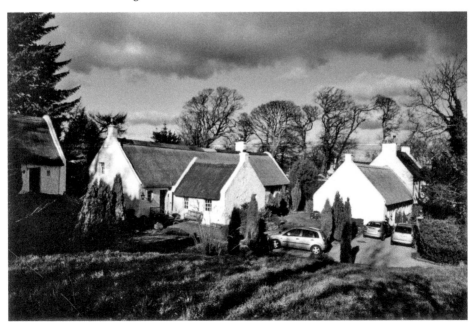

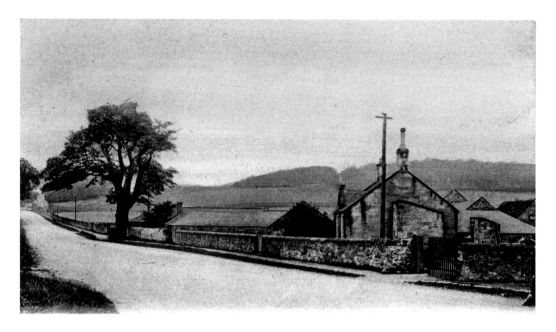

Little France and Queen Mary's Tree

Little France comprised of a handful of cottages along the road to Dalkeith but purportedly acquired the name after French troops encamped here in the mid-1500s during the reign of Queen Mary. The history of the sycamore tree is debatable, but is said to have been planted by Mary, Queen of Scots in 1566 while staying at nearby Craigmillar Castle and, until around 1980, a metal plaque commemorated this. Both the plaque and the tree have now gone.

The district has taken on new significance since 2003 when the new Royal Infirmary opened, replacing the Victorian version in Lauriston Place. The University's Medical Campus is also on this site.

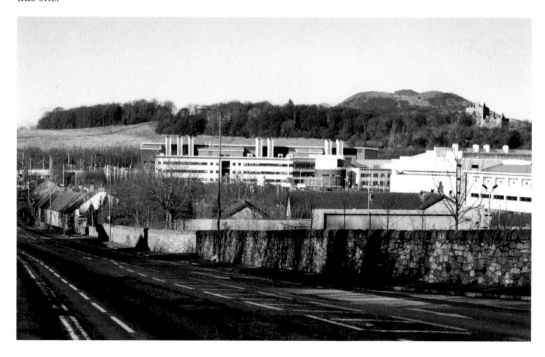

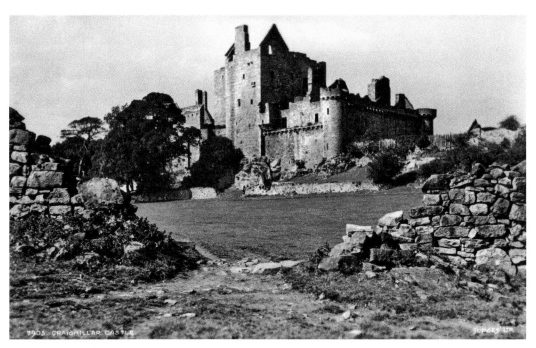

Craigmillar Castle

This splendid structure on top of a rocky promontory has, at its core, a fifteenth-century tower house whose walls are nearly 3 feet thick. It is thought to be similar to David's Tower, which was once part of Edinburgh Castle. Subsequently (exact date unknown) a high curtain wall, with a circular tower at each corner, was built around it.

Mary, Queen of Scots favoured the castle as a country retreat, particularly after events in 1566. Early that year, her trusted aide, David Rizzio was murdered in Holyrood Palace and a few months later she gave birth to her son (future James VI of Scotland) while the relationship with her husband, Lord Darnley, continued to deteriorate.

The Preston family were the first occupants, but then sold it to Sir John Gilmore in 1660 who, by the eighteenth century, chose to move to the more modern Inch House. Historic Scotland now manage the fascinating labyrinth and surrounding parkland.

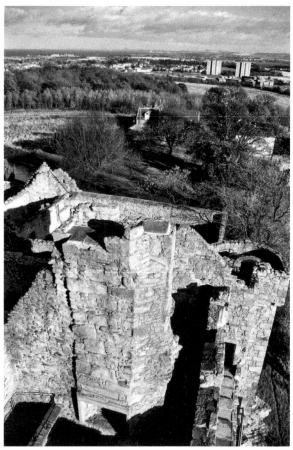

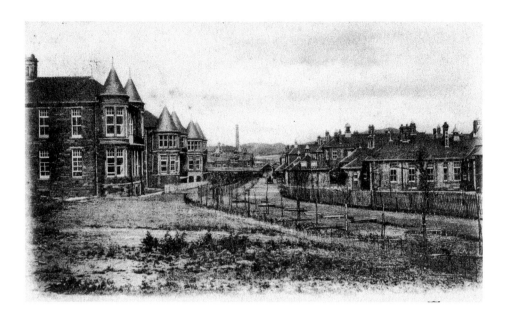

Colinton Mains Hospital

By the end of the nineteenth century, a hospital dedicated to infectious diseases was desperately needed as the City Fever Hospital in High School Yards was proving inadequate to deal with epidemics of infections such as cholera and smallpox.

The City Hospital, as it became known, was opened in 1903; the design by architect Robert Morham consisted of parallel turreted wings with end balconies; best practice in these pre-antibiotic days was for patients to have as much fresh air as possible. In 1913 a unit was added for patients with tuberculosis, which, by 1952 was cured by 'triple therapy', a protracted and unpleasant treatment.

Closed in 1999, the hospital complex has been converted to upmarket housing.

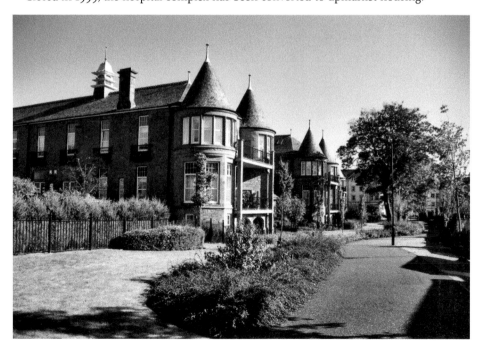

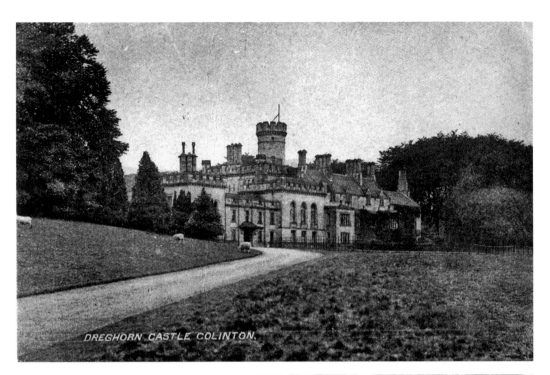

DREGHORN CASTLE COLINTON.

Dreghorn Castle

This mansion was built in 1658 for Sir William Murray, Master of Works to Charles II, on land above Colinton village and overlooked by the Pentland Hills. Over the next 200 years, the estate changed hands frequently but was purchased by Robert Andrew Macfie in 1862, who was responsible for erecting a monument to the Covenanters, using ionic columns from the old Royal Infirmary when it was demolished in 1884. This is still standing, unlike the house, which was demolished in 1955. Locals believe it was used for target practice by the neighbouring Dreghorn Barracks. The wooded policies still provide a pleasant walk.

59

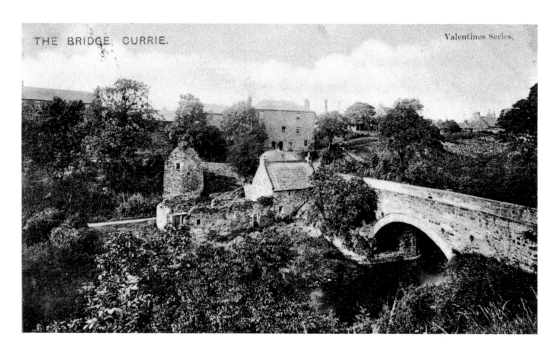

Currie Bridge

The Water of Leith flows for 18 miles from the source in the Pentland Hills to the mouth at Leith and has been utilised over the centuries by people and livestock along its course. The village of Currie lies in the upper reaches – now within the western boundary of Edinburgh – and straddles both sides of the water, necessitating a bridge. The present one dates from 1896, but the original single-arch is thought to have been at least 500 years old and reference to bridge repairs appear in church records of 1599. The ruins of Currie Mill are visible in the old photograph. Mountaineer Dougal Haston was born in Currie, and spent his boyhood climbing local stone walls, particularly by the railway. He was the first Briton to climb the summit of Mount Everest in 1975.

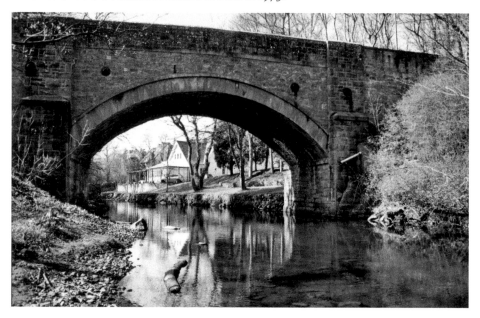

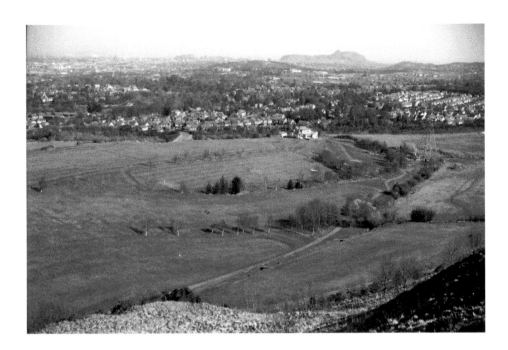

Torphin Hill Golf Course, Juniper Green

Further downstream from Currie is the district of Juniper Green where both paper and snuff mills were situated on the banks of the Water of Leith. The southern edge of the village is on the low slopes of the Pentland Hills and the site chosen for Torphin Hill Golf Course in 1903, although the club formed eight years earlier. The elevated fifteenth tee is marginally higher than the summit of Arthur's Seat, the latter landmark being the centrepiece of a wonderful vista across the city, East Lothian and Fife.

Part of the course is on the eastern side of Warklaw Hill, which was extensively quarried.

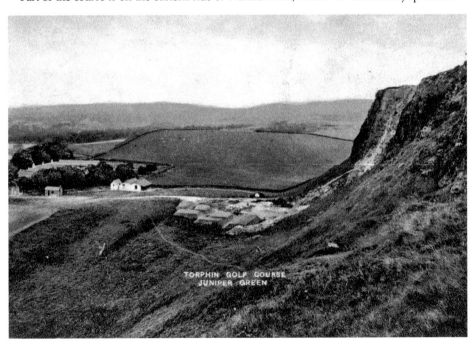

TORPHIN GOLF COURSE
JUNIPER GREEN

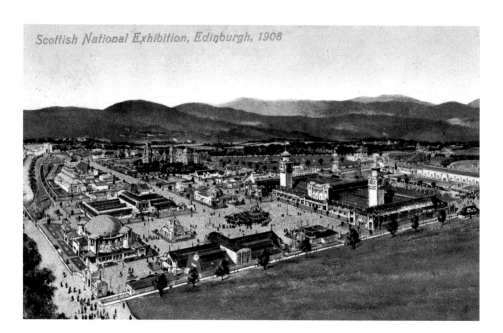

Scottish National Exhibition, Saughton

1907 marked the bicentenary of the Treaty of Union between Scotland and England, and Edinburgh planned to hold a National Exhibition to commemorate it, until discovering that a similar event was happening in Dublin, so it was brought forward by twelve months. The grounds of Saughton House, having been bought by the council in 1900, were filled with custom-built amusements such as water chute, helter-skelter and even a mock-up Senegalese village as well as industrial and concert halls. It was an unqualified success.

Saughton Park remains a public amenity, although dense housing has reduced the acreage, and has recently added both a skateboard park and new play area.

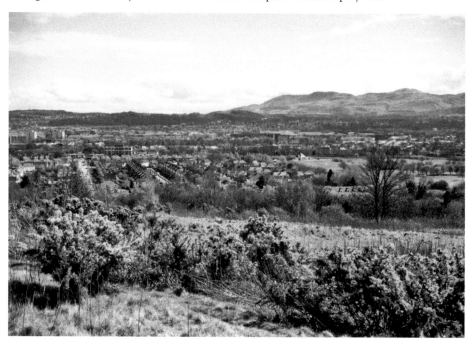

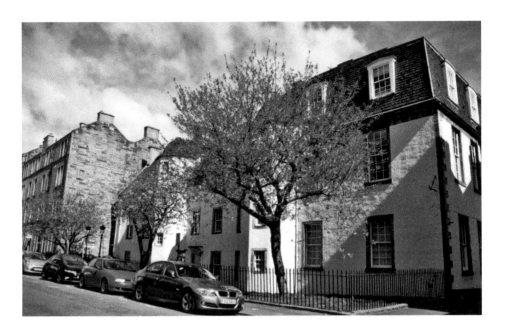

Dalry House

The attractive seventeenth-century Dalry House of today could easily be missed – an oasis sandwiched in a desert of tenements in the narrow Orwell Place. It has been divided into private flats but has a diverse history. In 1870 it was purchased by the Scottish Episcopalian Church for general schooling for the poor, only part of which was religious instruction, but two-year courses were also started for training the teachers. By 1928, student numbers were so low that courses became part-time and a hostel was started, but in 1934 both ceased. The queen opened a day centre here for the elderly in 1965.

The house is reputed to be haunted by a one-armed ghost, the spirit of John Chiesly, who lived locally in 1680s. Strangely, a one-armed skeleton was dug-up under a Dalry cottage in 1965.

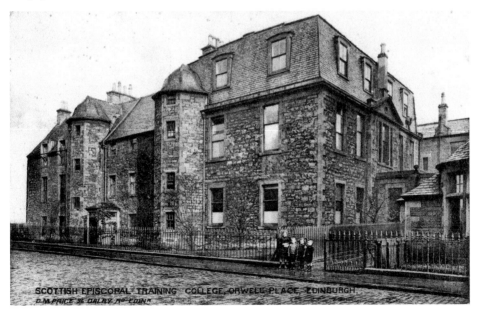

SCOTTISH EPISCOPAL TRAINING COLLEGE, ORWELL PLACE, EDINBURGH.
D.M.PRICE 36 DALRY R⁰ EDIN⁺

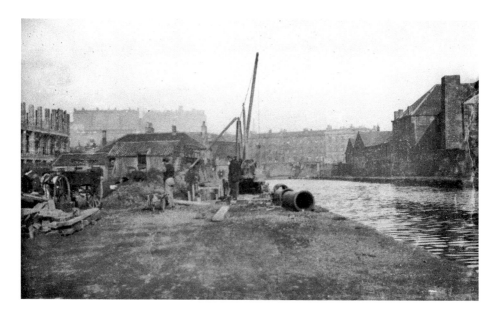

Union Canal

The Union Canal linking Edinburgh to Glasgow opened in 1822. The approach to the basins of Lochrin, Port Hamilton and Port Hopetoun (the latter two were filled in when the canal became disused commercially) passed through the industrial eastern suburbs of Dalry, Gorgie and Slateford, choc-a-bloc by 1870 with working-class Victorian tenements. The creation of the canal encouraged industrial development of factories and breweries in the vicinity, helped also by close proximity to the railway.

Over the last decade, Lochrin Basin has been transformed into a contemporary commercial centre of offices, restaurants and apartments with colourful houseboats moored on the water. To the left of the colour image, McEwan's Fountain Brewery stood for 145 years until it was cleared away in 2011, having closed in 2004.

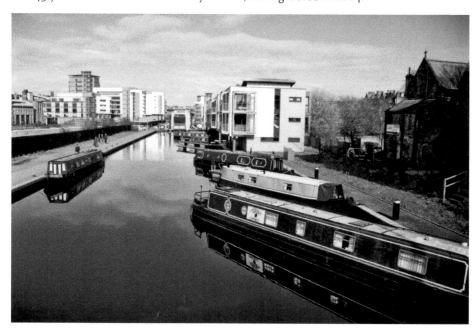

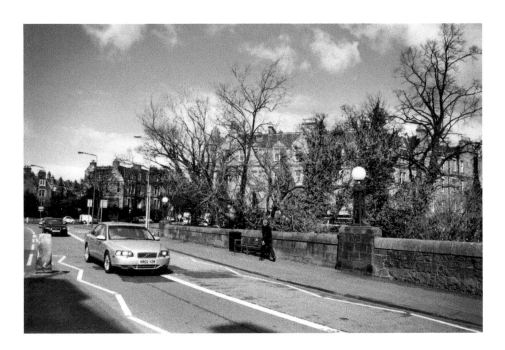

Murrayfield Bridge

The main route into Edinburgh from the west crosses the Water of Leith at this point over Roseburn (sometimes called Murrayfield) Bridge but formerly known as Coltbridge. It was here that, in 1745 during the Jacobite uprising, Bonnie Prince Charlie's Highland troops approached Edinburgh, terrifying the Dragoons of John Cope's cavalry, who then fled to Leith Links, allowing Prince Charles to enter Holyrood unopposed. This became known as the 'Coltbridge Canter'.

The present road bridge was built in 1841, but the narrow eighteenth-century one close by is still used by pedestrians.

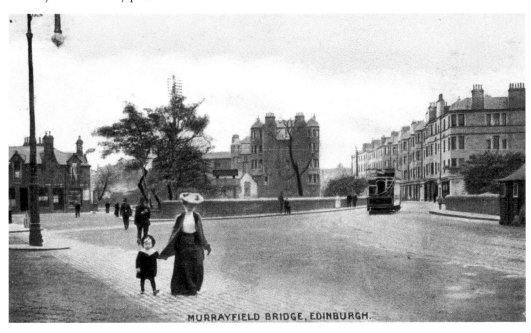

MURRAYFIELD BRIDGE, EDINBURGH.

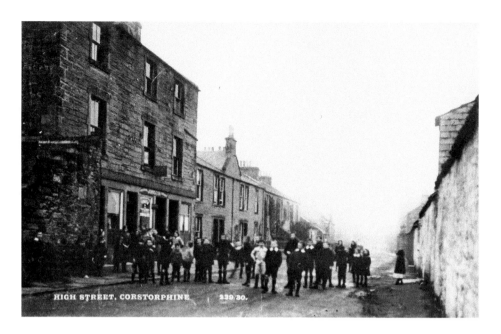

HIGH STREET, CORSTORPHINE. 239/30.

Corstorphine High Street

Remnants of the medieval settlement at Corstorphine can be sought out amid the built-up Western suburb of Edinburgh. Situated 3 miles from Old Town at the foot of Corstorphine Hill, it boasted its own castle, which was dismantled in the eighteenth century, although the beehive doocot is entire and in the good care of Historic Scotland; it had the capacity for 1,000 birds, an important food supply.

The original High Street, seen here, is parallel to the A8, the main thoroughfare today. On the eastern corner, the unusual, slab-roofed Old Parish church has ecclesiastic origins from the twelfth century, and retains some parts from the 1400s. The village became integrated into Edinburgh in 1920; the farmland has since been covered by housing.

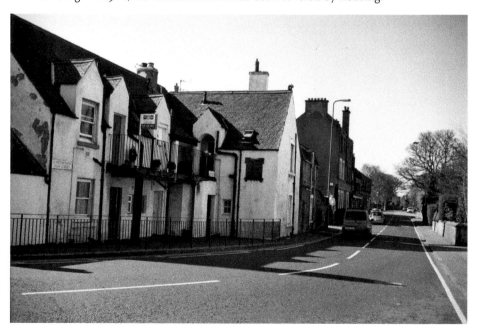

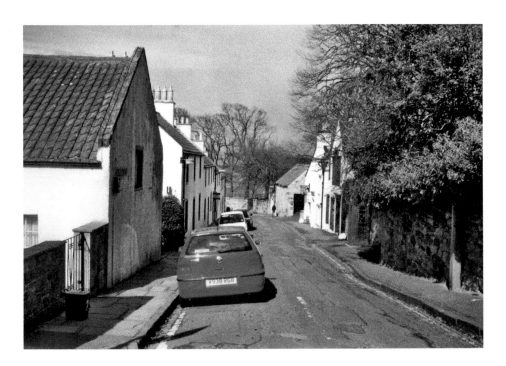

Cramond Village

This strategic point where the River Almond flows into the Firth of Forth was chosen by the Romans for a garrison on the east bank, easily connecting to the Antonine Wall further up the river. In 1997, a large Roman artefact was found in the estuary silt by the local ferryman; this lioness statue is on show in the National Museum of Scotland.

The medieval period is represented by a tower house, restored and inhabited, and the tower of Cramond Kirk. The far end of the (now) Cramond Inn on the right of the slope was built in 1670, but during the eighteenth century, the local hostelry was down beside the river. Between the road and the water are parallel rows of pretty crow-stepped cottages.

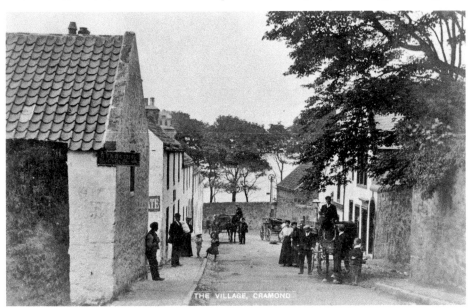

THE VILLAGE, CRAMOND

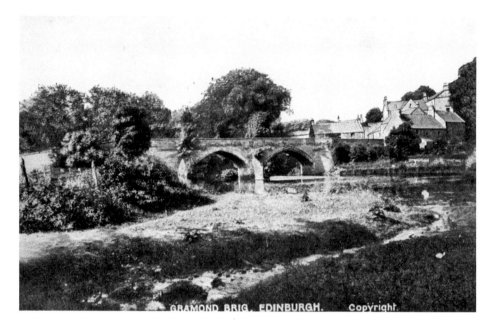

GRAMOND BRIG, EDINBURGH. Copyright.

Cramond Brig

This bridge crosses the River Almond about a mile upstream of the main village. First constructed around 1500, it required repairs throughout the following three centuries but is still used as a footbridge, on the far side of which is the Cramond Brig Hotel. During the seventeenth and eighteenth centuries, water-powered mills appeared along this stretch of water, first for grain, then iron and as the markets changed they became pulp mills; one – Cockle Mill – was restored in 1970 as offices and is presently a coffee shop and B&B. In 1826 the village went into decline, partly due to a local landowner implementing new farming methods and destroying several buildings.

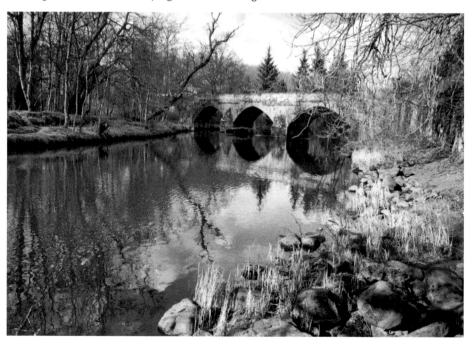

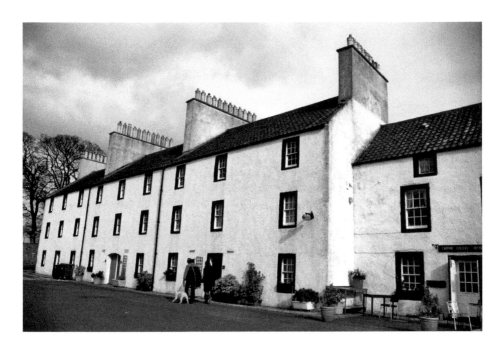

Cramond Island

This view has been transformed over the last seventy years. Firstly, in 1935 the beach was built up to create a promenade fronting the houses. Then, during the Second World War a causeway was constructed between this point and Cramond Island as a submarine defence boom; whilst this is a functional, rather than attractive structure, it makes for a good walk at low tide. After the war the houses were smartened up, and along the quayside, the Boat Club attracted pleasure craft, whose moorings add colour to the modern-day estuary. Cramond has certainly been rejuvenated.

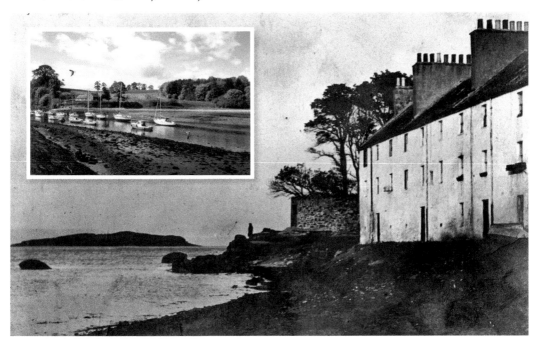

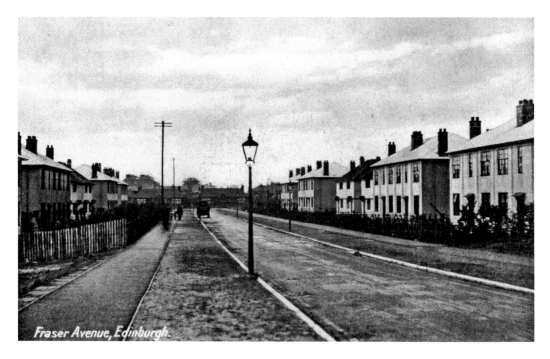

Fraser Avenue, Edinburgh.

Fraser Avenue

Edinburgh's housing requirements continued to increase into the twentieth century. In 1919, the Housing (Scotland) Act was passed, obliging local authorities to provide houses for the working classes and one of the first areas to benefit was close to Granton, at that time a busy harbour. The first streets completed, on what had been the Wardie Estate, were named after the Boswall family, who had owned it. The next phase involved funding from a Dunfermline Housing Trust and included the steel-built houses of Fraser Avenue, named after the provost of that Fife town.

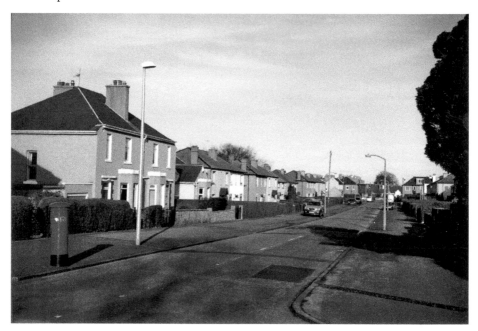

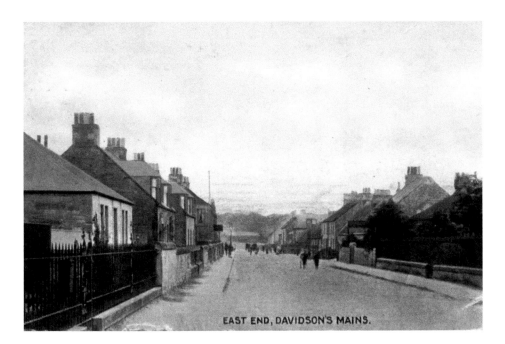

EAST END, DAVIDSON'S MAINS.

Davidson's Mains

A rural parish known as Muttonhole, this community did not significantly expand until after the Second World War, although the opening of the branch line between Craigleith and Barnton by the Caledonian Railway in 1894 heralded the changes that were to come. The name comes from the Davidson family of Muirhouse, who were wealthy traders, living in a mansion on Marine Drive.

The entrance to the park at the west end of the village still has a well, from which water had to be drawn until 1932, when a residents' water trust managed to have pipes laid to the spring on Corstorphine Hill.

MAIN STREET

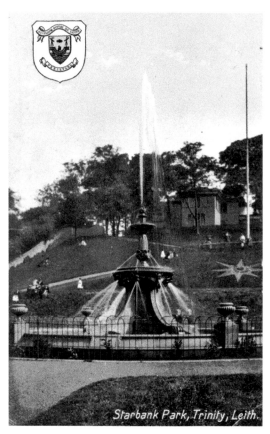

Starbank Park, Trinity, Leith.

Starbank Park

Thomas Devlin purchased a steam-powered trawler in 1884, and the business quickly grew into a large family concern. Their enterprise at Granton's Eastern harbour provided locals with employment and even workers' houses, and the 'brand' – Devlins – was painted on the rolling railway stock. In its heyday before the First World War, Granton would see up to eighty vessels leave port, most belonging to Devlin. By 1910, Devlin was a wealthy man and paid for a drinking fountain to be erected in Starbank Park, just above the shoreline on Granton Road. The business was finally dissolved in 1984.

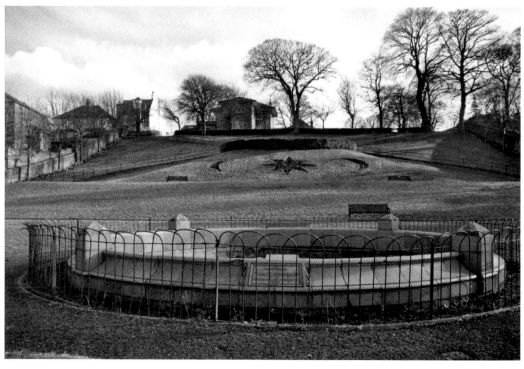

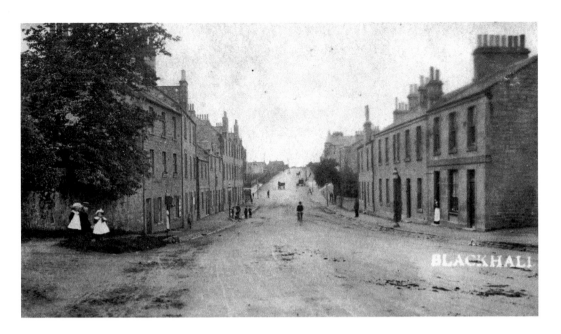

Blackhall

This was another rural part of Edinburgh's hinterland until the turn of the twentieth century, apart from the large quarry at nearby Craigleith, the sandstone from which much of New Town was built. After the Second World War the site was gradually filled in and a large supermarket has been placed there, but with an ironic footnote: the stone for the entrance to the store was quarried in Northumberland!

Development started after Craigleith station opened in 1879. A succession of amenities followed – bowling club in 1898, church of St Columba in 1903, primary school in 1907 and lawn tennis club in 1915, all helping to give Blackhall community an identity of its own.

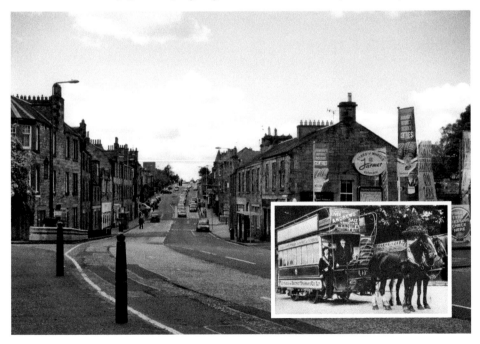

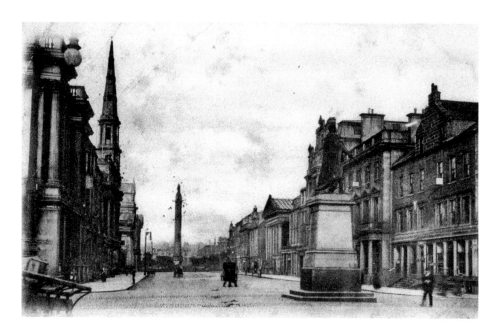

George Street

'Proposals for Carrying on Certain Public Works in the City of Edinburgh' was the title of a pamphlet presented to the Town Council of Edinburgh in 1752. The acceptance of this proposal was to change Edinburgh forever.

Lord Provost George Drummond had been acutely aware that the insanitary, overcrowded Old Town, where some tenements were starting to fall down, was not sustainable and radical change was urgently needed. The plan submitted by James Craig won the competition in 1766. The linear layout centred around a main thoroughfare atop the ridge of Bearford's Park, named George Street, after King George III, and punctuated at either end by open squares around gardens.

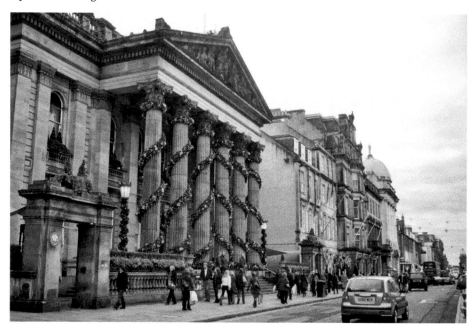

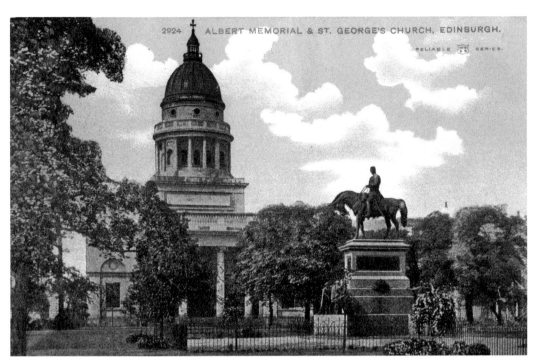

Charlotte Square

James Craig planned to have churches at the extremities of both squares as pleasing end points to George Street. However, the politician, Sir Laurence Dundas, who owned some land on the east of the ridge, upset the layout of St Andrews Square by building a grand house in 1771.

At the West end, Charlotte Square was the last section of this phase of New Town to be built. Elegant, classical design by architect Robert Adam, using the durable stone from Craigleith makes this square one of the best examples of the influence of eighteenth-century Scottish Enlightenment.

The domed church of St George's (now West Register House) was opened in 1814, albeit not using Adam's design. The central gardens come into their own in August each year as the venue for the Edinburgh International Book Festival, overlooked by the statue of Prince Albert.

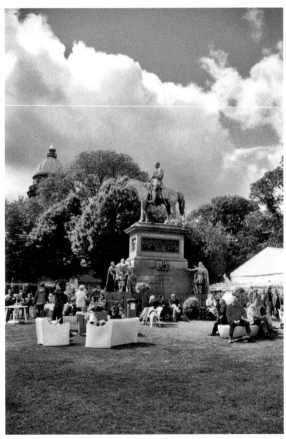

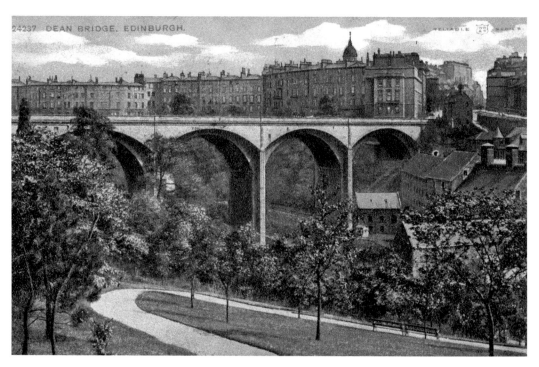

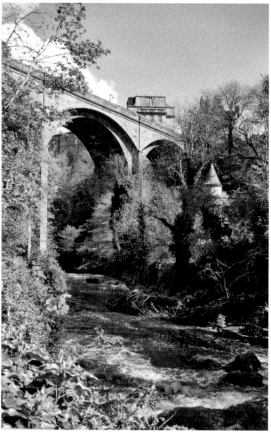

Dean Bridge

'...I have stood in Queen Square, or the opening at the north-west corner of Charlotte Square, and listened to the ceaseless rural corncraiks, nestling happily in the dewy grass. It would be some consolation if the buildings were worthy of the situation; but the northern houses are turned the wrong way, and is sacrificed to the multiplication of feuing feet.' From *Memorials of His Time* by Lord Cockburn.

Thomas Telford's spectacular bridge over the Water of Leith opened in 1831, facilitating further development to the north-west. Over 100 feet high, it spanned the steep valley, in the bottom of which, lay the old mill community of Dean Village.

It must be many years since a Corncrake was heard around Edinburgh! Nowadays they are confined to the north-west of Scotland and Ireland.

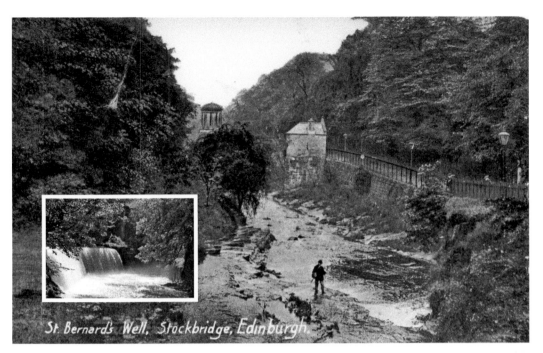

St. Bernard's Well, Stockbridge, Edinburgh.

St Bernards Well

Between the north-west corner of the first New Town and the sheer wooded gorge of Water of Leith was the estate of the Earl of Moray. Demand was so great for houses on the northern side of Edinburgh that he decided to feu his land in 1822 for development. The resulting graceful crescents of Moray Place, Ainslie Place and Randolph Crescent sit atop the cliff at the foot of which is St Bernards Well. It was discovered in 1760 and the popularity of the mineral waters' therapeutic effects led to it being protected from pollution by a stone well-house. Then, in 1788, the characterful judge, Lord Gardenstone, himself a believer of the benefits of the water, purchased the well and commissioned Alexander Naesmyth to design a temple, similar to one in Tivoli with the goddess Hygeia inside. Further upstream, near the dam of Dean Village's West mill, another well – St Georges – enjoyed brief popularity.

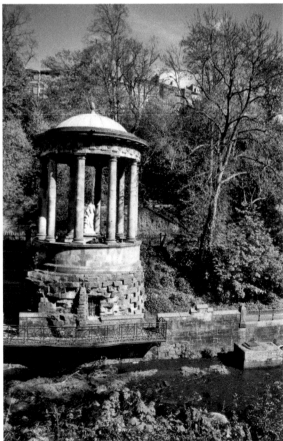

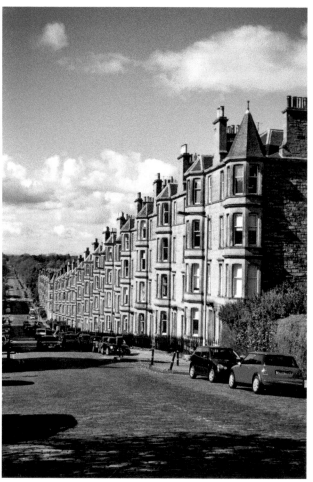

Comely Bank Street

The northern expansion of Edinburgh continued unabated. In 1894, a Lanarkshire builder called James Steel had hit bad times and came to Edinburgh to make his fortune – he did that and more. Lord Provost John Learmonth, who had paid for Dean Bridge to be built, owned land to the north-west which he sold to Heriot Trust. Their plans to invest in housing there coincided with James Steel's arrival in the city and he was responsible for the wide sloping streets of Comely Bank. He also built other large-scale developments such as Tolcross and Merchiston and ultimately was knighted, being a very wealthy man by then.

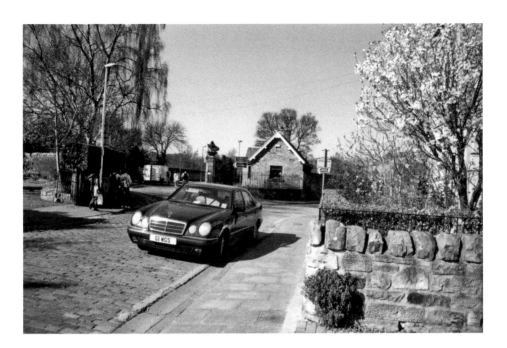

Arboretum Avenue

The northern edge of Stockbridge leads into the Inverleith estate, the house and policies of which were purchased from the Fettes Trust in 1877 to enlarge the Botanic Gardens. Arboretum Avenue allows a pleasant walk between the two locations, with the Water of Leith flowing along the right hand side and the greenery of the old Raeburn Estate on the left (now playing fields). The cottage in the picture was built in 1789 as the South Lodge to Inverleith House. Glenogle Road veers to the right of it, crossing the ornate Falshaw Bridge, which replaced a wooden footbridge and ford in 1877 – an improvement on the earlier stepping stones.

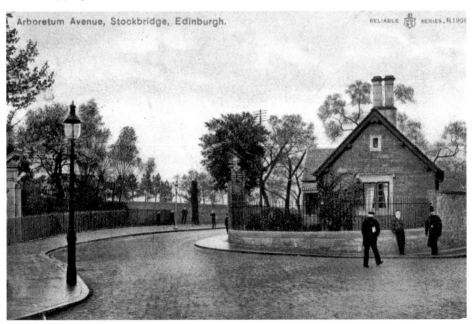

Arboretum Avenue, Stockbridge, Edinburgh. RELIABLE SERIES. R.1956

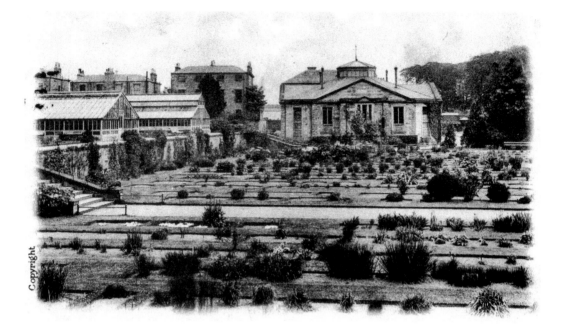

Royal Botanic Garden Edinburgh

The beautiful and important public amenity in the policies of Inverleith House has evolved over four sites, and almost as many centuries, from humble Physic Garden in the Old Town to modern centre of research, conservation, teaching and recreation. The move from Haddington Place was completed by 1823; during the transfer, the then curator, William McNab, invented a novel contraption for moving mature trees without damaging the roots. A decade later, the Tropical Palm House was erected, followed by the Temperate one in 1858; these are the earliest glasshouses in Edinburgh. Next year, 2013, a new Alpine House will be opened with plants being grown in tufa, rather than pots.

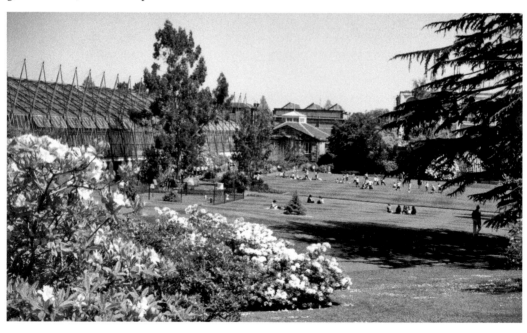

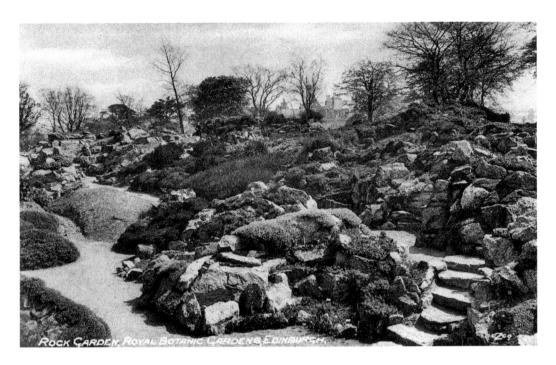

Rock Garden

The first attempt at creating a rock garden was made by James McNab in 1903, but it did not meet with the approval of the Regius Keeper and a more imaginative one was initiated in 1908, using a variety of rocks and shapes, more commensurate with the topography of Scotland. It has matured into an aesthetically pleasing corner of the gardens, rich with colours, textures and botanical diversity at all times of the year. The large and sylvan oasis within the city naturally attracts birdlife and it is noteworthy that rare Hawfinches nested here until 2001.

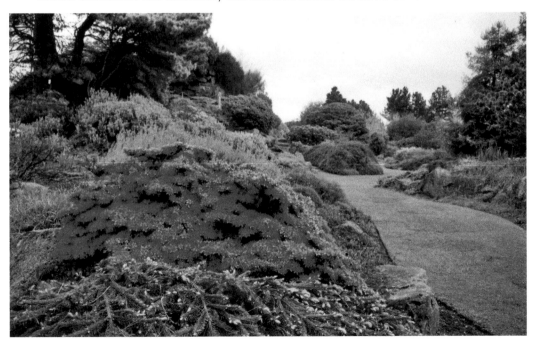

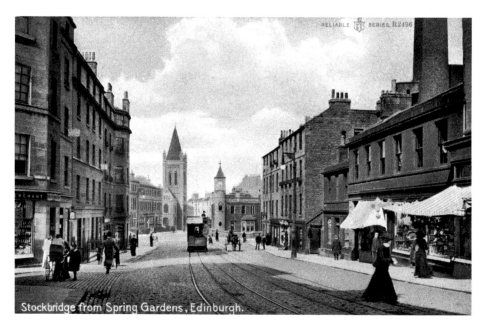

Stockbridge from Spring Gardens, Edinburgh.

Stockbridge

Until the nineteenth century, Stockbridge was a community of farms, mills and tanneries, clustered around the Water of Leith. The steep approach to the valley from Edinburgh entailed fording the river or crossing the wooden footbridge, both of which were tricky during spates or with a heavy cartload. A stone bridge was constructed in 1786, replaced by the current road bridge in 1901.

The boundary of New Town continued to move closer, amoeba-like, until the district was eventually swallowed up as a northern suburb of the city, albeit with a high standard of architecture and attractive gardens, particularly in Henry Raeburn's Deanhaugh Estate. A village atmosphere still abounds, with many independent, quirky shops; the bohemian St Stephens Street is particularly well-known.

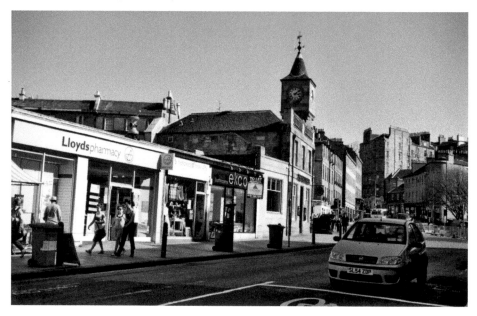

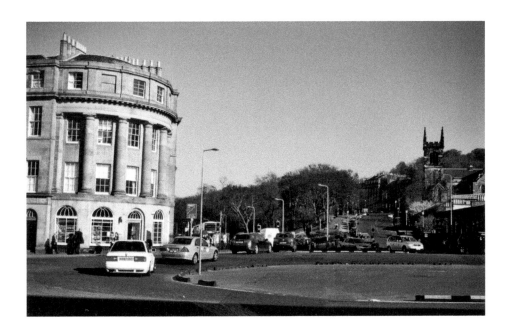

London Road and Royal Terrace

In the seventeenth century, the traffic passing here would have been sedan chairs and hackney carriages travelling the country route between Old Town and the port of Leith. Behind the Gothic Greenside Church is the gentle eastern slope of Calton Hill and the ubiquitous architect of the day, William Playfair, proposed another New Town development here, extending towards Leith. In the 1820s Regent Terrace – facing south – and Royal Terrace, fronted by large gardens, were completed and are some of the most elegant Georgian houses in the city. On the opposite side of London Road, Hillside Crescent and its radial streets still comprised of grand houses, but the superior masterpiece of Royal Terrace looked down on them, literally and metaphorically. The hierarchy was to continue all the way north to Leith.

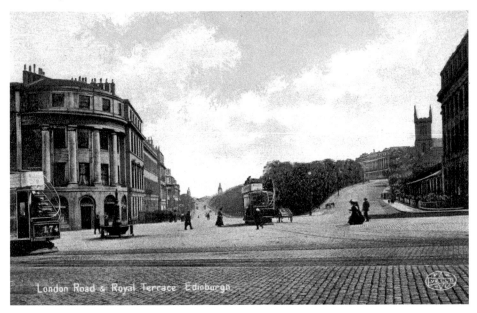

London Road & Royal Terrace Edinburgh

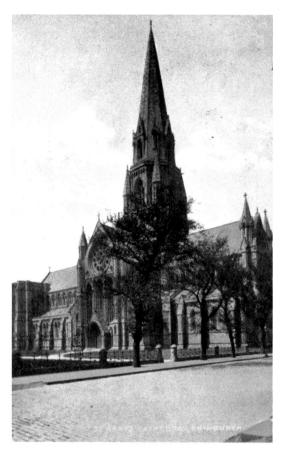

St Mary's Cathedral

The Victorian Gothic design of St Marys, consecrated in 1879, reflected the era in which much of the western expansion of the city took place. St Giles in Old Town had been the cathedral of Edinburgh, but events of the nineteenth century led to many changes. Firstly, the exodus from Old into New Town had left the High Street an impoverished, squalid, possibly dangerous place to visit. Secondly, the schism in the established church, caused by The Disruption in 1843, resulted in many new churches being built.

Two sisters, Mary and Barbara Walker from Easter Coates left all their land to the Episcopalian Church with express wishes for a cathedral to be established in the Diocese of Edinburgh. The three lofty spires are an unmistakable part of the city's skyline.

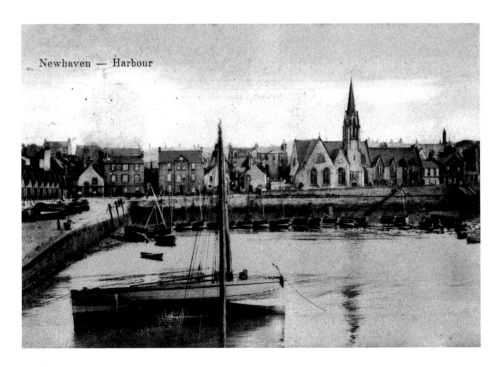

Newhaven — Harbour

Newhaven Harbour

Newhaven is on the southern shore of the Firth of Forth, 2 miles north of Edinburgh's Old Town, and separate from it until the twentieth century. James IV of Scotland hoped to create a Scottish Navy, and in a big gesture, commissioned the Newhaven dockyard to build the immense *Great Michael* which was launched in 1511, but the plan was aborted after Flodden in 1513. Fishing has always been the main industry, although ferry services to Fife operated for a while until taken over by Granton Harbour in 1844, and the distinctive fish market on the left was put up in 1896.

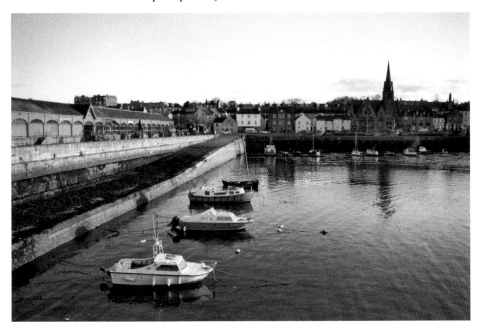

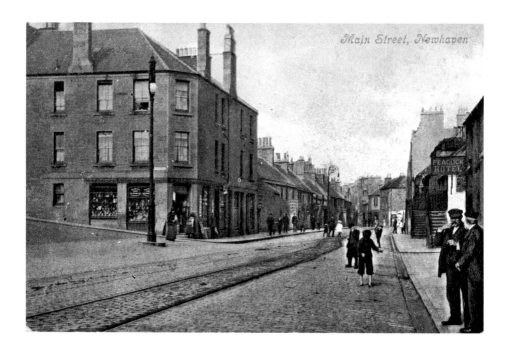

Main Street, Newhaven

The western end of the cobbled main street is now closed off, but the greatest changes are social. Pleasure craft outnumber scant fishing boats in the harbour, the bustling groups of fishwives are long gone and even the general stores on the north side of the street closed its doors recently. In the 1960s, much of the property was in poor condition and Edinburgh City Council started a development plan; there was an unsympathetic housing block built on the south side but the old fishermens' cottages opposite, with outer forestairs, have been conserved. The enormous Victoria Primary School further along is the oldest local authority one still used in Edinburgh.

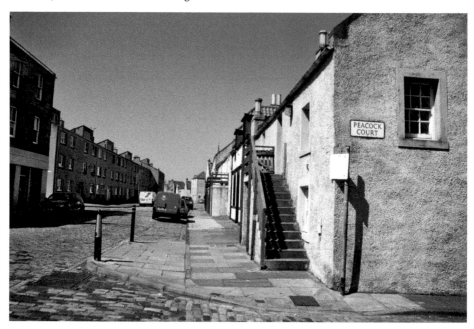

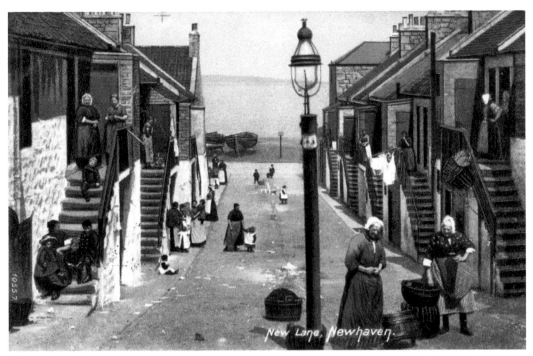

New Lane, Newhaven.

Newhaven Closes

It is easy to imagine the cramped living conditions of the past; the cottages in the closes, which were at right angles to the harbour, had ground level stores for creels and nets and the steps to the upper accommodation used as seats by the fishwives when baiting the lines, mending nets and catching up on gossip. The intimacy of this close-knit community contrasts starkly with Edinburgh's Waterfront development, looming into view behind Newhaven Harbour. The vast regeneration project, instigated by Forth Ports Ltd, began in Leith in the 1980s and plans to stretch through Newhaven to Granton.

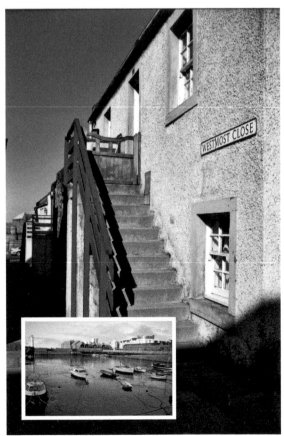

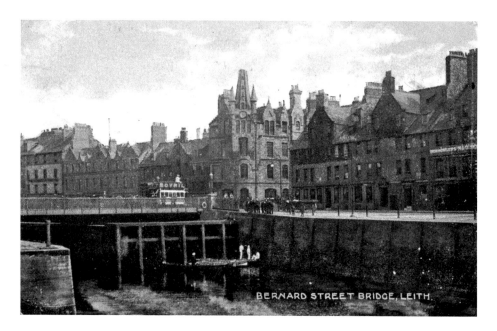

Bernard Street Bridge, Leith

The Water of Leith flows into the Firth of Forth just downstream from here and historically divided South Leith – on the right of photograph – from North Leith. Upstream, the three-arched Brig o' Leith had existed since the fifteenth century and was replaced in 1778 by the Upper Drawbridge at Sandport, followed by a similar crossing (Lower Drawbridge) joining Bernard Street with Commercial Street. This was demolished at the end of the nineteenth century, replaced by the present one. By this time, Victoria Swing Bridge, the largest of its type in Britain, had been constructed in 1874. The contemporary view to it from Bernard Street Bridge is one of floating restaurants, moored in front of executive apartment blocks.

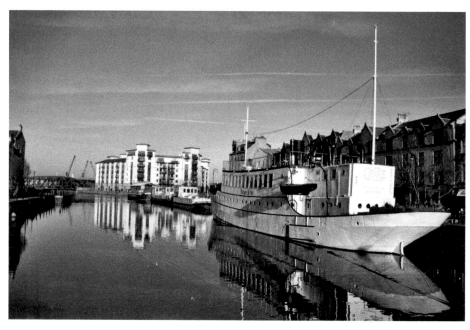

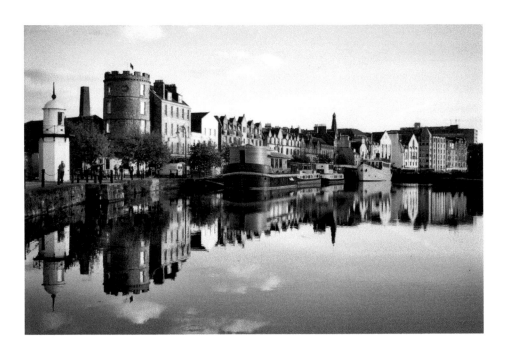

The Shore

The Burgh of Leith had enjoyed 87 years of independence from Edinburgh, thanks to the City Agreement act of 1838, and so was opposed to re-absorption into its centuries-long oppressor in 1920. Ninety years later, however, it has a new wealth, not related to the traditional sea port trade, but to fashion; it has become *de rigueur* to reside in Leith. After the Second World War, the area fell on bad times; shipyards closed, railway services were withdrawn, the docks declined and Leith became synonymous with prostitution and drug culture. In the 1990s, the Shore became popular for restaurants and bars and the Seamen's Mission was converted into a luxury Malmaison Hotel. Waterfront developments followed and a rapid transformation has come to pass.

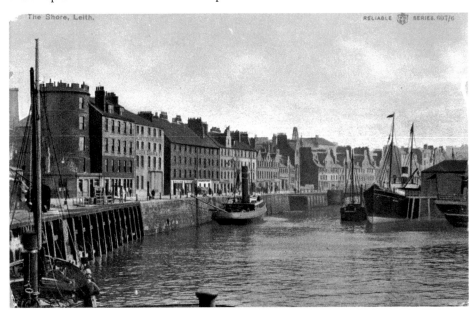

The Shore, Leith.

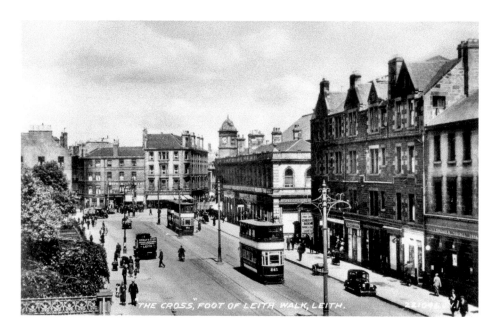

THE CROSS, FOOT OF LEITH WALK, LEITH.

Foot of Leith Walk

Prior to the present road, the route between the city and the port was along the line of Easter Road, or the Wester equivalent through Bonnington. In 1650, a series of defences against Oliver Cromwell was put up along the line of Leith Walk, and because this track was shorter, it became the adopted path. Over the eighteenth and nineteenth centuries the country estates along here feued their land for housing as Edinburgh rapidly extended her boundaries.

In 1872, Leith started a horse-tram service, superseded by electric ones in 1905. Edinburgh meanwhile was running cable cars and, in typical uncooperative style, both only went as far as Pilrig, making it necessary for passengers to change from one system to the other. Partly to capitalise on the situation, North British Railways laid a track to Leith Central.

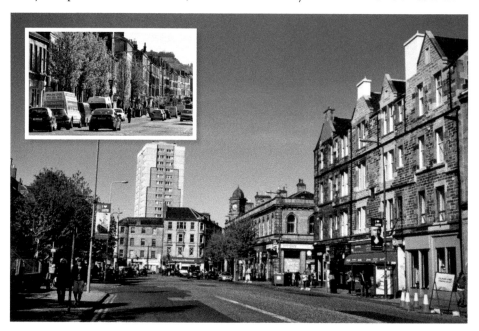

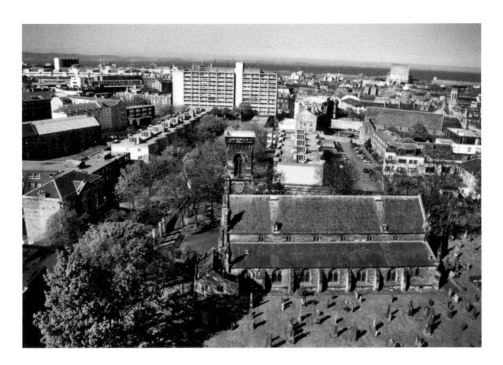

South Leith Parish Church

The history of this goes back over 500 years. Originally called St Mary, it was a cruciform chapel paid for by Trade Guilds (Scottish Incorporations) and was built in 1490. During The Seige of Leith, when the infant Mary Queen of Scots was sent to France, her mother, Mary of Guise, acting as Regent in Edinburgh, moved parliament to Leith and resided in a house in Water Street. In 1560, when the protestant bombardment ended the siege, the church was badly damaged and over the next three centuries was repaired and remodelled several times. The church seen today in Kirkgate, Leith's original high street, is from 1846.

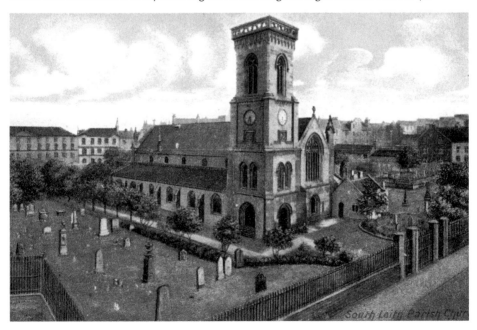

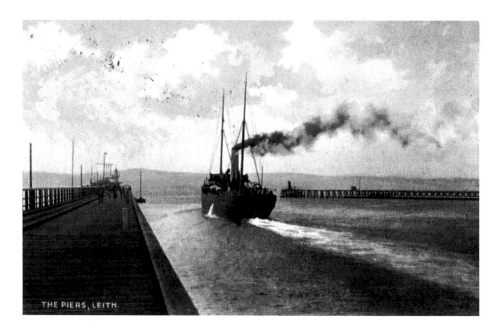

THE PIERS, LEITH.

The Piers, Leith

When the mouth of Water of Leith first became the port of Edinburgh in 1329 it was little more than shelter and anchorage. In the eighteenth century when more docks were required, it was realised that, unlike Newhaven harbour, the water was too shallow for large vessels and shifting sandbanks impeded their passage. Various piers and breakwaters were tried in the early nineteenth century until a major scheme, including land reclamation for docks, took place over the next few decades. Expansion has continued and the entire area has been regenerated. Ocean Terminal complex, opened in 2001, occupies land on which stood the Henry Robb shipyard and behind it Royal Yacht *Britannia* is moored, near which the old wooden posts of West Pier slowly rot away.

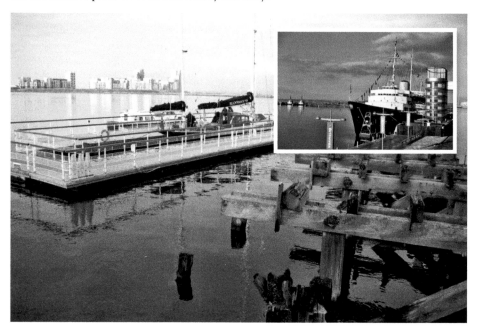

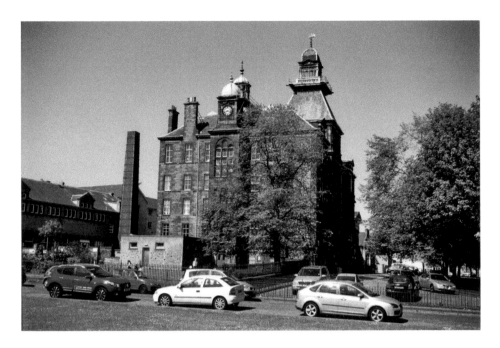

Leith Academy

In 1555, when French troops were occupying Leith, The Fraternity of Masters and Mariners of Leith built a hospital in Kirkgate (Trinity House) in which the pupils of the Leith Grammer School were educated until 1710 when they moved to St James Hospital in the grounds of South Leith Parish Church. Poor conditions for the children motivated the public to donate £3,000 to build a new school and this was done by 1806 at western edge of Leith Links. The blue blazers sported a version of the Leith Flag as school badge. The school has just celebrated the 450th anniversary, but not from this building, which is now the Primary School, but from a state of the art complex opened in 1991.

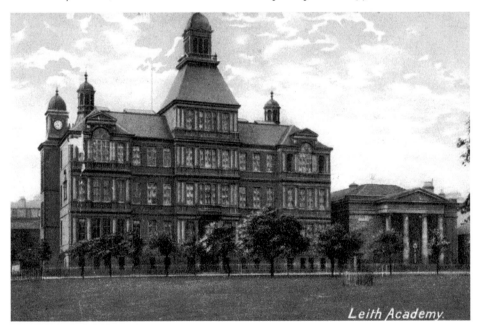

Leith Academy.

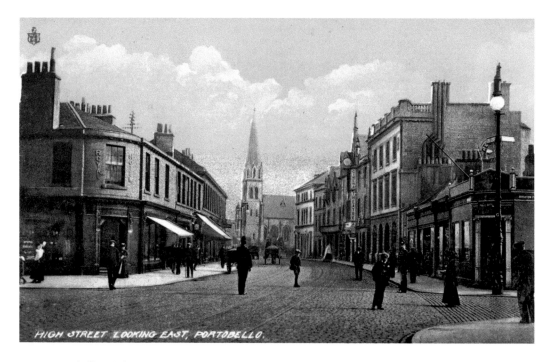

HIGH STREET LOOKING EAST, PORTOBELLO.

Portobello High Street

In the mid-1700s, three miles east along the Forth Estuary from the thriving Port of Leith, was a long, quiet stretch of sand, behind which was rough coastal heath called The Figgate Whins, remarkable only for one thatched cottage and a burn. In 1753 an enterprising Edinburgh builder discovered a clay bed here and started a brickworks; he went on to build seven villas and two potteries and by the turn of that century, an attractive village had evolved to which city dwellers started to visit for the sea, and sand. In 1832 Portobello became a burgh, although absorbed into Edinburgh City in 1896.

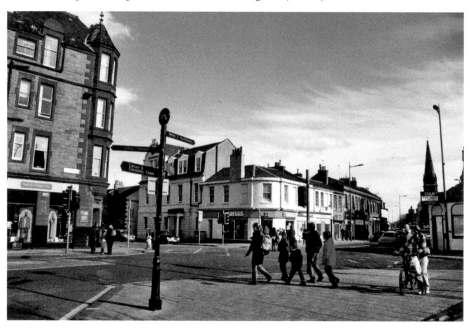

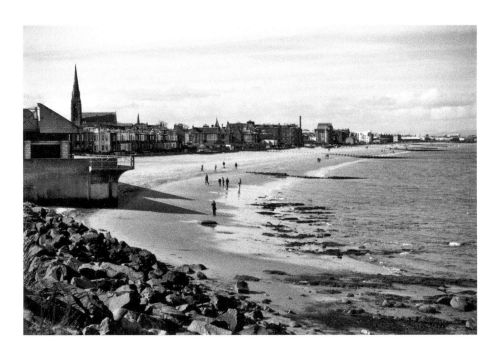

Portobello Sands

The popularity of Portobello as a seaside resort peaked in Victorian times and tenement blocks from that era still dominate the promenade. Regular trams and trains carried crowds of day-trippers from the city for a day at the seaside and the breezy walk along the pier (1870), destroyed by a storm in 1917. The Marine Gardens at Seafield were created using the structures that had been put up for the National Exhibition at Saughton in 1908, but the First World War put paid to them. In 1936, Portobello's famous outdoor swimming pool, complete with a wave-making machine, was built, and although shut in 1984, still evokes happy memories.

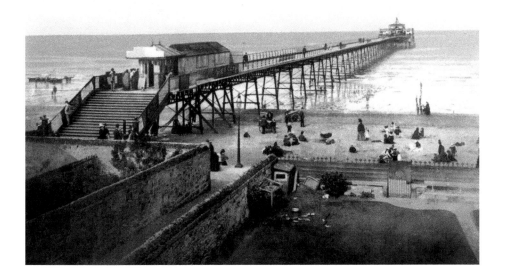

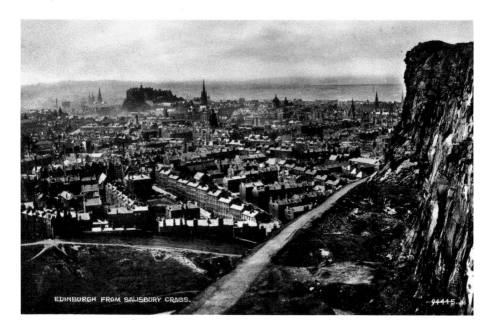

EDINBURGH FROM SALISBURY CRAGS.

-94445-

View from Salisbury Crags

The topography of Edinburgh lends itself to myriad views in every direction, with little exertion. The igneous outcrop of Salisbury Crags below Arthur's Seat affords a perspective of the city and its history, growing out from the pinnacle of Castle Rock and bounded by Corstorphine Hill in the distance and the cobalt water of the Forth below a backdrop of the Ochil Hills near Stirling. Reminders of its evolution abound: the density of housing in the valley below as in the early days of Old Town, the vertical crag rocks where James Hutton began his theory of geology during the Enlightenment and the rough Radical Road, hacked out by unemployed weavers, after an episode of civil unrest in 1820. Both the history and the landscape are colourful.

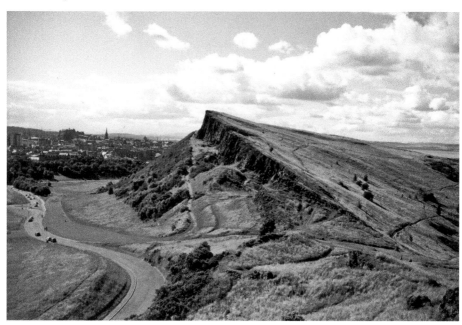